IMAGES
of America

BEAVERHEAD
COUNTY

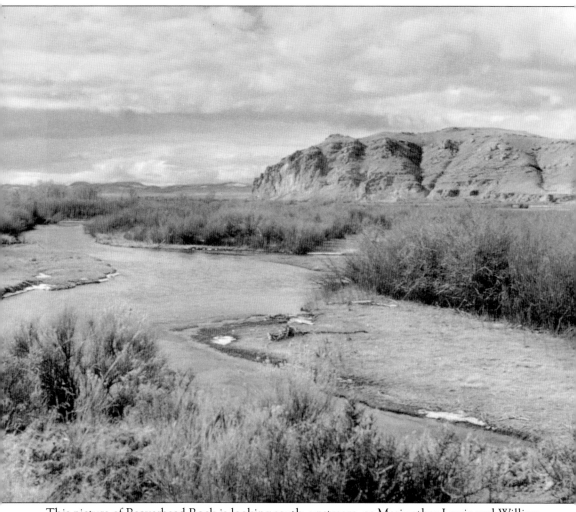

This picture of Beaverhead Rock is looking south, upstream, as Meriwether Lewis and William Clark would have seen it pulling their dugout canoes up the river. It was Sacajawea who pointed out the now famous rock outcropping to the captains and told them her people called it the Beaver's Head because of the resemblance to that animal. Chief Justice Lew L. Callaway of Helena wrote in 1910, "We should preserve its name . . . for tradition and history, and not suffer it to be dubbed with the all too common and nearly meaningless name of 'Point of Rock,' which carries no distinction. . . . forefend us from this pseudonym." (Courtesy of Beaverhead County Museum Photo Archives.)

ON THE COVER: Here is the harvesting of the tallest wheat ever grown on a dry farm. Without water for irrigation, Norman Holden in 1912 worked in cooperation with Montana State College in Bozeman to test various crops in dryland farming practices. The East Bench lands above the river east of Dillon were without access to water for irrigation. Fifty years later, the Bureau of Reclamation brought irrigation water to this area with the East Bench Irrigation Canal. (Courtesy of Beaverhead County Museum Photo Archives.)

IMAGES
of America

BEAVERHEAD
COUNTY

Stephen C. Morehouse
and the Beaverhead County Museum

ARCADIA
PUBLISHING

Published by Arcadia Publishing
Charleston SC, Chicago IL, Portsmouth NH, San Francisco CA

Printed in the United States of America

Library of Congress Catalog Card Number: 2008928324

For all general information contact Arcadia Publishing at:
Telephone 843-853-2070
Fax 843-853-0044
E-mail sales@arcadiapublishing.com
For customer service and orders:
Toll-Free 1-888-313-2665

Visit us on the Internet at www.arcadiapublishing.com

To my grandchildren, Lauren and Cole, and future generations to come.

CONTENTS

ACKNOWLEDGMENTS

Thanks to the Beaverhead County Museum's past and present directors and volunteers who have spent hours preserving and filing all the photographs and history, of which only a small part is able to be shown in this book. During the past 30 years, I have listened to the Meine family as they shared a part of the history of the area with me. Thanks to Bette Meine Hull, the museum director, who found files, photographs, and information for me, even bringing from home her own personal collection. A special thanks to Joan McDougal, retired Dillon librarian, who gave me guidance and assistance. Ben Goody from Glendale contributed the material on the Hecla Consolidated Mining Company, as well as other historical research. Adding to my introduction to local history were Dick Kennedy, Vince Pendleton, Jess Warrick, Eddie Reynolds, and Dolores "Buzz" Tash. I enjoyed their stories of history and family. At Western Montana College, my children and I learned history from Prof. Dale Tash. Dan and Bobbie Jean Scott and Ted and Barbara Renfro brought Armstead to life with stories, pictures, and old papers. Bob Meine, Art Christensen, and W. W. "Doc" Hawkins shared stories that could only be told in first person. Mark Sant with the U.S. Forest Service and long-time Dillon resident and educator Charles "Chuck" Cook added information on the area.

In 1998, I met the Arriwite family from Fort Hall, members of the Lemhi Shoshone Community, who shared with me their oral history. I am thankful to the elder Leo Arriwite and his son Leo T. Arriwite.

Thanks to the Beaverhead County Museum Association Board of Directors and the Beaverhead County Museum Board of Trustees, along with the chamber of commerce, who thought this publication would add to visitor understanding and appreciation of our beautiful county and state. I am grateful for the support from Hannah Carney and John Poultney, my editors at Arcadia Publishing.

Lastly, I want to thank my wife for supporting me and postponing some of the projects we were going to do once we retired.

Unless otherwise noted, all images are courtesy of the Beaverhead County Museum Photo Archives.

INTRODUCTION

The average elevation of Beaverhead County is 6,000 feet, surrounded on three sides by the Continental Divide. This puts it at the top of the Missouri River drainage; from here, the river flows north then east through Montana to the middle of America, joining the Mississippi River before reaching the Gulf of Mexico. When these two rivers are combined, as geographers do, calling it one water system, it becomes the third longest river in the world behind the Nile and Amazon. Most geographers believe the Missouri and not the Mississippi is the main river.

Capt. Meriwether Lewis wrote on August 10, 1805, while walking west up Horse Prairie Creek in Beaverhead County, "I do not believe that the world can furnish an example of a river running to the extent which the Missouri and Jefferson's rivers do through such a mountainous country and at the same time so navigable as they are."

Lewis understood the value of the Missouri and its drainage. With three men, he continued walking west into Idaho, found the Shoshone Indians, and brought them back to the two forks of the Jefferson River, now under Clark Canyon Reservoir. Here they met Capt. William Clark and the rest of the party and set up a camp that Clark would call "Fortunate Camp." It was here that Sacajawea was reunited with her people; the chief turned out to be her cousin. (In Shoshone culture, cousins are referred to as brothers and sisters.) The captains traded for horses and a guide to take them over the mountains to the Columbia River. If not for the help of Sacajawea's band—the Agaidika, or Salmon Eaters—the expedition would not have been able to proceed.

After Lewis and Clark, the area was visited by various trappers and traders. Jim Bridger came through in his travels. In 1841, Fr. Pierre Jean DeSmet came through on his way to the Bitterroot Valley. James and Granville Stuart came to the Beaverhead in the fall of 1857 to spend the winter at the mouth of Blacktail Deer Creek (Dillon). Here they meet Richard Grant and his sons, who were wintering footsore and worn-out cattle and horses they had traded for from emigrants on the Oregon Trail in Utah. This stock was usually of good quality and only needed rest. The Grants would spend their summers along the emigrant trail trading two jaded animals for one good one, and in the fall, they drove their stock back into Montana.

Montana was a part of Missouri Territory until Missouri became a state in 1821. Then Montana became Indian Territory. When Nebraska became a territory, Montana became part of it, then a part of Dakota Territory in 1861, and finally, in 1863, it became a part of Idaho Territory. Sidney Edgerton was appointed chief justice of the eastern part of Idaho Territory by U.S. president Abraham Lincoln, but when he arrived in Bannack, he found such lawlessness and terrorism by the road agents that he was unable to enforce any order.

With Lewiston, Idaho, as the capital, it was geographically impossible to govern Montana hundreds of miles away over snow-clogged mountain passes. Sidney Edgerton traveled back to Washington, D.C., to petition for a new territory. On May 26, 1864, President Lincoln signed into law the Organic Act creating Montana Territory, appointing Edgerton its first governor. Bannack was chosen as the first territorial capital. By February 1864, the vigilantes had hanged the road agents. In 1889, Montana became the 41st state.

Other towns started up as more gold and silver was discovered. As the population grew and the demand for goods increased, the railroads became interested in the region. Both the Northern Pacific and the Utah and Northern approached Montana in 1879. Both companies proposed building to the heart of the silver mining country at Butte and Helena. The Utah and Northern had the shorter route and, with Union Pacific backing, reached Montana first, crossing the line at Monida on March 9, 1880. The plan was to press north and winter over along the river near the mining town of Glendale. This would have put them at the present location of Melrose. As the track laying crews proceeded down the Beaverhead, they found their way blocked at the junction of the river with Blacktail Deer Creek. An Irish bachelor by the name of Richard Deacon owned a 480-acre ranch that included all the bottom land between the benches on each side of the valley. The railroad had to cross his property, and he did not want to grant them the right-of-way. The railroad could have had the land condemned by the right of eminent domain, but Deacon promised a court battle. He gave the railroad only one choice: they had to buy the entire ranch. Knowing the Union Pacific officials would not stand for that, Washington Dunn, the construction superintendent, went to the businessmen who traveled with the railroad, setting up a temporary or "Terminus" town to service the large construction crews. He proposed that if they would buy the land, he would stop there for the winter, allowing them time to establish a more permanent community. On September 8, 1880, the Terminus businessmen met at Simeon Estes's stage station and ranch at Barrett's, the old Ryan toll gate, and agreed to pool their money. They went to Deacon and bought the ranch for $10,500; they then laid out a town and sold lots, making a profit of $3,500. Included in this group of men were B. F. White, J. E. Morse, Edward S. Ferris, L. J. Ruth, Joe Schlessinger, Charles Lefever, Howard Sebree, J. M. Barrett, and Sim Estes. In honor of the construction superintendent, the group agreed to call the new community Washington City. Dunn declined the honor and suggested they name the town after the president of the Union Pacific Railroad, Sidney Dillon. The group agreed, and the new town became Dillon. Sidney Dillon never saw the town named for him.

It took 10 days for the instant town to take shape, and by December, passengers started arriving from Ogden 347 miles away. The narrow 3-foot-gauge track was the longest narrow-gauge line in the world.

Considerable permanent construction took place over the next several years. Dillon became the county seat in 1882, taking it away from the waning town of Bannack.

In 1883, the *Dillon Tribune* reported there was nearly a continuous stretch of wood sidewalk on Montana Street. Numerous fires wiped out many of the early wooden buildings. When the buildings burned, they were usually replaced with well-built brick structures, many of which are still in use today. The Corinne Hotel burned, and on the site, the Metlen Hotel was built in 1897. The first brick school was constructed in 1883; the block was given to the county. There have been successions of newer and bigger schools built since then. Currently, there is only one of the older brick school buildings left, and that one houses the kindergarten. The State Normal College was built in 1893, and today the original main hull remains part of the college campus. Cattle and sheep ranches established 140 years ago still operate today. Beaverhead County is the oldest county in Montana. Dillon, the county's largest city, serves as the county seat.

One

THE AGAIDIKA AND BANNOCK TRIBES

The first people to come into southwest Montana followed the retreating glacial ice sheets, looking for food and the materials (sharp stone) needed for tools. Evidence suggests they came around 12,000 years ago. Shoshone oral history includes stories of large prehistoric animals. The Shoshone, like other cultural groups, are made up of individual bands, each with their own separate history and traditional homeland. The different bands identify themselves with the dominant food source in their territory. The Agaidika, or Salmon Eaters, are from the Salmon and Lemhi River areas of Idaho. In the deep canyon, downstream from Salmon, were the Tukudeka, or Sheep Eaters. Today the Agaidika use "Lemhi" Shoshone to differentiate them and to show regional location of their last piece of homeland—the Lemhi Valley. Their original homeland was much broader and knew no state or county boundaries. They traditionally traveled between the Salmon River in Idaho to the three forks of the Missouri in Montana and south into Yellowstone Park. Living among the Agaidika was a band of Bannocks, who are of the Paiute Tribe and a different linguistic stock. The town of Bannack is named after them; however, the spelling was changed and never corrected. When gold was discovered in 1862, pressure was put on both the tribes living here. By 1868, the influx of emigrants had displaced the peaceful Shoshone and Bannock to a provisional reservation on the Lemhi River south of Salmon, Idaho. In 1875, the Lemhi Indian Agency was established, but in 1880, the government wanted to move them to the Fort Hall Reservation. Their treaty was not ratified until 1889, at which time a stipulation was added that they would not move to Fort Hall until a majority of the adult males agreed to do so. That happened in 1907, shortly after the death of Chief Tendoy. The Lemhi Shoshone now live on the Shoshone-Bannock Reservation at Fort Hall in southern Idaho.

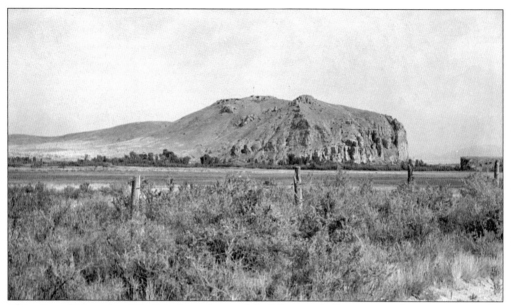

This view of Beaverhead Rock is from the south looking north downstream. It is easier to see the resemblance from this view, but it is not known when or from what direction the person naming the landmark first viewed it. The name had been passed down from generation to generation through Shoshone oral history. It has now become a part of history.

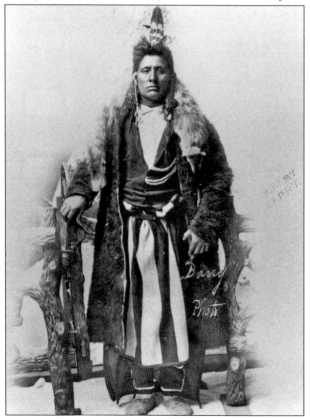

The photographic archive of Shoshone and Bannock people in the Beaverhead County Museum is sparse. As they were displaced by European settlers, the Shoshone and Bannock spent more time in Idaho. This photograph and those on the opposite page were taken by a local photographer with no other information. This man is identified as Wolf Chief, a relative of Sacajawea. This means he is an Agaidika (Salmon Eater) or Lemhi Shoshone, as they are commonly referred to today. Note the animal skin over his shoulders.

Pictured here are Lemhi Shoshone children. Cloth clothing has replaced deer skins. The older girl wears earrings and a pendant of the highly valued abalone shell.

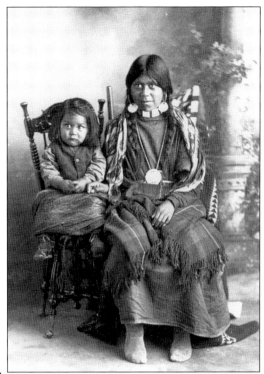

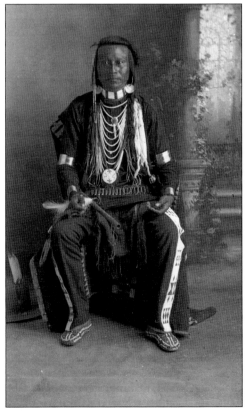

A Lemhi Shoshone man wears abalone-shell earrings. He has a flute in his lap, the butt of a pistol can be seen on his left side, and he is wearing a cartridge belt.

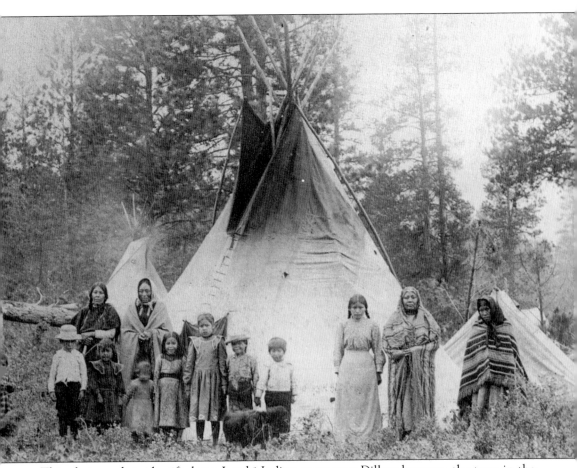

This photograph is identified as a Lemhi Indian camp near Dillon; however, the trees in the background indicate the picture was not in fact taken near Dillon because Dillon's dominant trees were cottonwoods. The picture shows the change in clothing around the start of the 20th century, going from deerskins to cotton and calico.

Chief Tendoy of the Lemhi Shoshone, a highly respected leader, was held in such esteem that he is memorialized by a Dillon street. Tendoy Street is the block-long street on the north side of the courthouse square. In addition to Tendoy Street, there is a Bannock Street and a Sacajawea Street in town, and Beaverhead Lane is just outside the city limits.

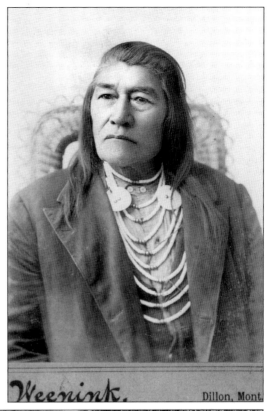

Weenink. Dillon, Mont.

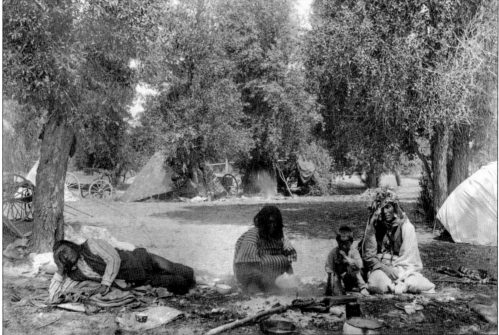

Chief Tendoy and his family are camped at a favorite camp site just north of Dillon called Selway Park. Note the cottonwoods, with horse-drawn wagons and traditional lodges.

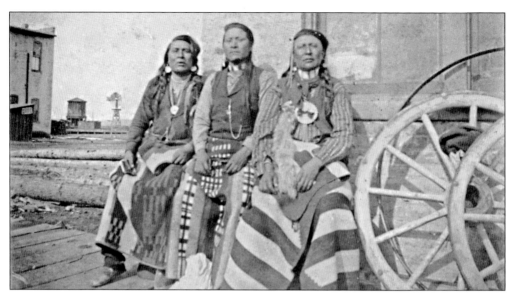

Chief Tendoy (center) is pictured in Dillon. Note the water tank and windmill in the background, part of the Utah and Northern Railroad.

Mattie Bear, a member of the Bannock tribe born in the late 1860s, would ride every summer from the Fort Hall Reservation, spending time in Beaverhead and Madison Counties. In her younger days, she washed clothes and picked and sold berries, along with her beadwork. She liked to spend time around Virginia City selling her beadwork and continued to return until 1936. She is pictured here in 1920 at the Ruby Valley ranch of Peter Anderson (Harding Ranch) while on her way to Virginia City.

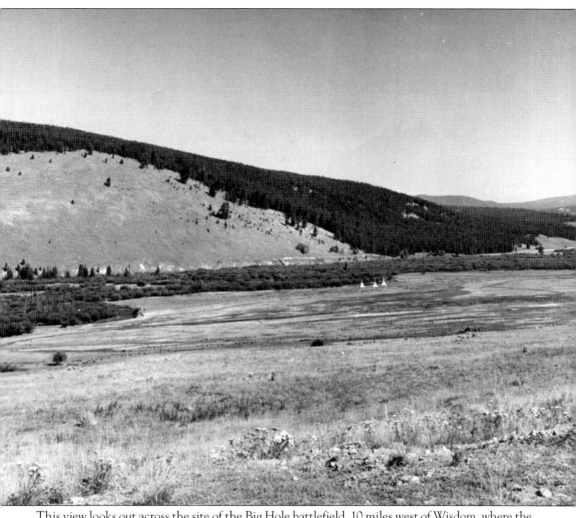

This view looks out across the site of the Big Hole battlefield, 10 miles west of Wisdom, where the army and the Nez Perce Indians fought one of the major battles of the Nez Perce War. In August 1877, Col. John Gibbon, in command of the 7th Infantry in western Montana, along with the Bitterroot Valley volunteers, tried to stop the five bands under the leadership of Chief Looking Glass. The non-treaty Nez Perce were fleeing Idaho, looking for a place where they would be left alone to live in peace with their allies, the Crow, in buffalo country.

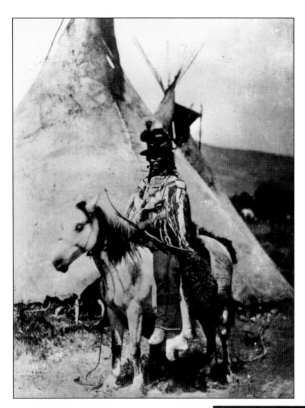

Chief Looking Glass decided to camp at an old site along the north fork of the Big Hole River. The five bands of 800 people with 2,000 horses thought they were far enough ahead of the army. Thinking they were safe, Looking Glass did not post guards and was not aware that Colonel Gibbon had come down from Fort Shaw west of Great Falls to join the chase and was advancing toward them. At dawn, the army opened fire and caught the camp asleep. In the ensuing battle, they would lose 10 women, 21 children, and 32 men. The army lost 29 soldiers and volunteers.

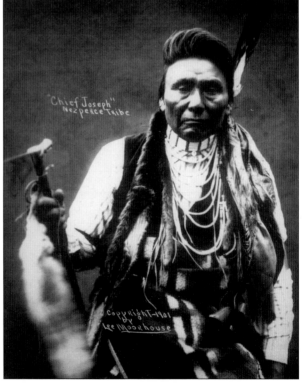

The Nez Perce fled with their wounded south through the Big Hole and Horse Prairie Valleys, then east through Yellowstone Park to Laurel and north to just south of Chinook, where they were finally stopped in the Bear's Paw Mountains before reaching the safety of Canada. Here, with Looking Glass and several other now dead chiefs, Chief Joseph surrendered to Col. Nelson A. Miles, stating, "From where the sun now stands I will fight no more forever."

Two

MINING AND MINERALS

In 1852, a trapper named Francois Finlay discovered gold near Gold Creek, which today is on Interstate 90 between Butte and Missoula. Finlay and other trappers had seen where mining in California helped to bring a decline to the fur trade there and decided to keep the gold discovery a secret. In 1858, brothers James and Granville Stuart, along with Reese Anderson, discovered gold on the same creek but did not have the sufficient tools to do any serious excavating, and they were unable to return with the proper equipment until 1862. The miners established a community known as American Fork at the mouth of the creek, and the creek took the name Gold Creek. When gold was discovered on Grasshopper Creek in 1862 by John White and a group of prospectors from Colorado, the rush was on. News of this fabulous strike flashed across the nation and became know as the "Grasshopper Diggins." Grasshopper Creek was originally named Willard's Creek by Lewis and Clark for Alexander Willard, a member of the expedition; however, White was not aware of this when he named the creek.

The first camp was set up 10 miles upstream from White's original discovery and by early fall boasted a population of 400. By the following spring, more than 3,000 miners had reached the Grasshopper Diggins. The camp was named Bannack for the Bannock Indians, who were affiliated with the resident Shoshone. Prospectors in Montana found silver mixed in with the gold deposits; however, silver was harder to process than gold. Gold could be filtered from the gravel with water, pans, sluice boxes, and later dredging, whereas silver had to be dug from underground mines and required stamping in a mill to break down the ore, which then had to be smelted. Silver also needed good transportation to be mined economically; the arrival of the railroad in 1880 was a boost to silver production. Processed silver could now be easily transported to national markets, and by 1883, the territory became the second-largest silver producer in the nation until the 1890s.

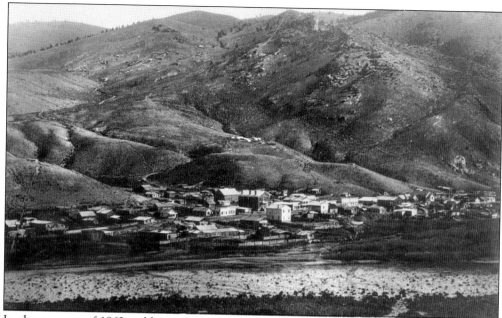

In the summer of 1862, gold was discovered on Willard's Creek, named by Lewis and Clark. Unaware of the existing name, the party of prospectors called it Grasshopper Creek because of the large numbers of hoppers, and the name stuck. Word quickly spread, and the town of Bannack sprang up almost overnight. By November, 500 miners had taken up residence at the Grasshopper Diggins.

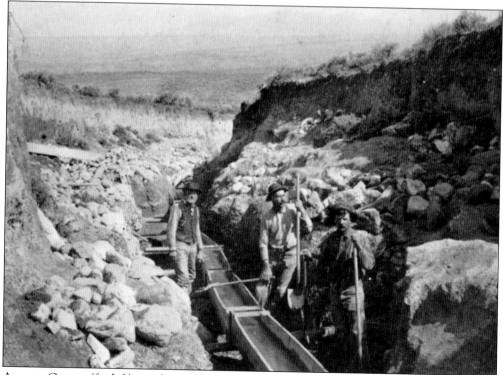

Agustus Graeter (far left) stands next to a sluice box used for extracting gold near Bannack.

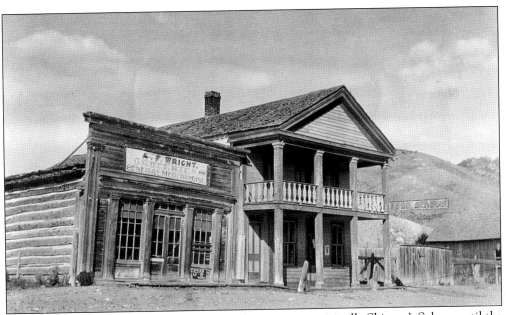

A. F. Wright Groceries and general merchandise store was originally Skinner's Saloon until the owner, Cyrus Skinner, was hung. To the right is the first hotel in Montana, the Goodrich Hotel (later the Bannack Hotel). The front of the hotel was removed and taken to Virginia City prior to demolition, and it became the front of the Fairweather Inn.

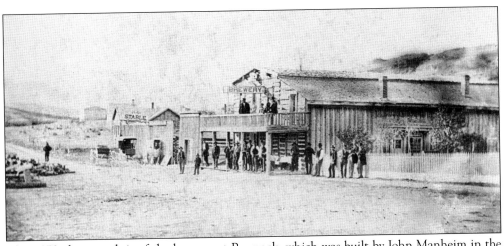

This 1870 photograph is of the brewery at Bannock, which was built by John Manheim in the spring of 1863, within six months after the town was started.

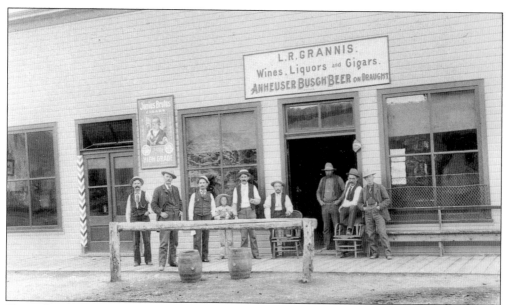

Shown here at the Grannis Liquor Store in Bannack in 1893 are, from left to right, Jack Marten, Babcock Noble, Mike Penaula, unidentified, Pete Monahan, Charles Wilson, Henry Lawson, Spot Gibson, and unidentified.

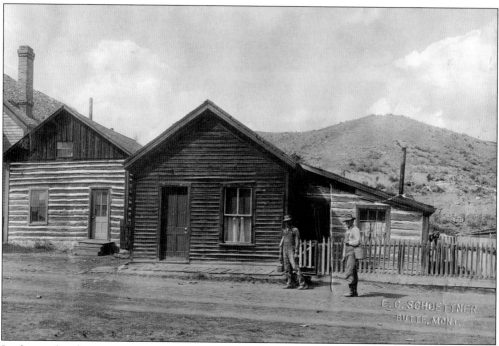

In this undated street scene in Bannack, two of the houses were owned by Amede Bessette. The man on the right is James Ashworth. Things were not always this quiet: with the gold came thieves. The year after the discovery of gold, it became dangerous to travel in and out of Bannack and unsafe to walk the streets after dark. In May 1863, Henry Plummer, the leader of the road agents, was elected sheriff and secretly led a reign of terror filled with robberies and murders against the hardworking miners.

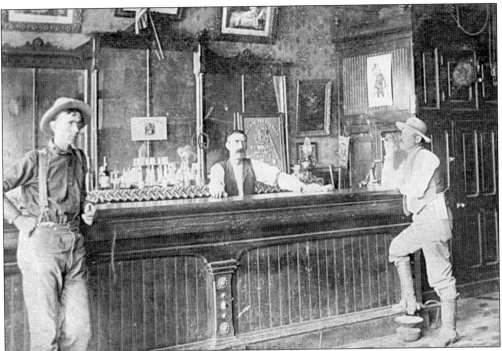

Saloons were a favorite hangout for the road agents. Cyrus Skinner, the owner of Skinner's Saloon in Bannack, served time in San Quentin with Henry Plummer and was a member of the gang of road agents. Skinner eventually met up with vigilante justice. The vigilantes were a group of citizens who organized to bring law and order where there were none.

The road agents' reign of terror lasted for 16 months, from the time Plummer came to Bannack in November 1862 until February 1864, when the last of the road agents were hanged. During this period of lawlessness, 102 alleged murders and numerous robberies were committed by this gang of men led by Sheriff Henry Plummer. The sheriff was hanged on January 10, 1864.

The Methodist church was under construction in 1877 when word of the battle at Big Hole with the Nez Perce reached Bannack. Work stopped for a few days as the town prepared for an attack. The Nez Perce, retreating with their wounded, were not looking for a fight and bypassed Bannack.

Known as "Brother Van," the Reverend William W. Van Orsdel was an early Methodist circuit rider. He became a general missionary in the Beaverhead Valley in 1873 and is given credit for establishing the Methodist church in Bannack and getting it built in 1877. He continued to be involved in the area through the early 1880s and would preach from the balcony of the Goodrich Hotel.

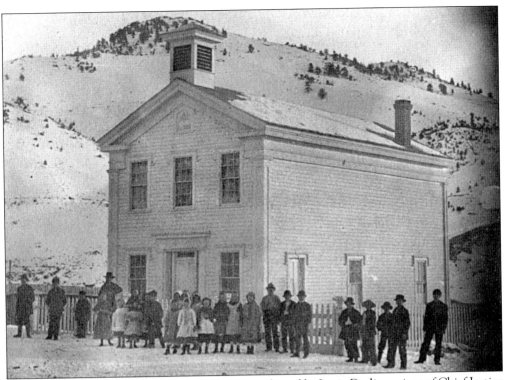

One of the first public schools in Bannack was conducted by Lucia Darling, niece of Chief Justice Sidney Edgerton. The first classes were held in the living room of the Edgertons' home in the fall of 1863. In the summer of 1864, a crude log cabin was built to serve as a school. Ten years later, in 1874, the Bannack Masonic Lodge No. 16 built this combination lodge and schoolhouse. The lodge was upstairs, and a single large classroom was downstairs. Classes were held here for nearly 70 years. The school closed in 1951.

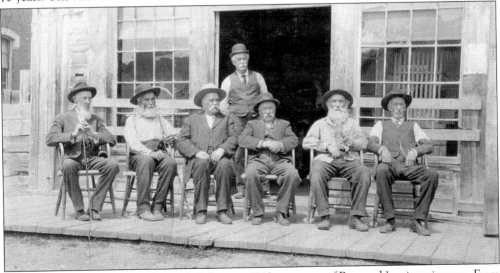

Pictured in front of the old Skinner's Saloon in 1912 are seven of Bannack's aging pioneers. From left to right are (seated) Fielding L. Graves, Joe Gauthier, Amede Bessette, Xavier Renois, Frank Gauthier, and William Wright; (standing) Archie Gibson.

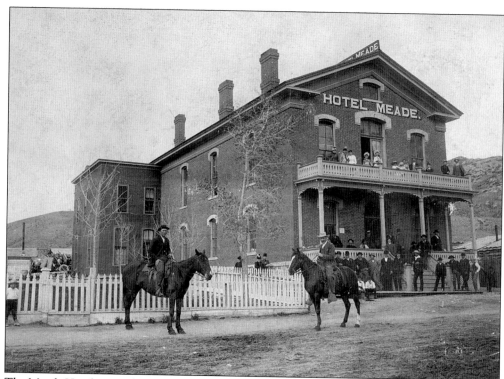

The Meade Hotel is seen here around the late 1890s. Note the new addition built onto the back to convert it into a hotel and restaurant. It was originally built as the Beaverhead County Courthouse in 1875–1876. It became a hotel when the county seat was moved to Dillon in 1882. Dr. J. S. Meade bought the building and ran it for 10 years as a hotel and restaurant from 1888 to 1898.

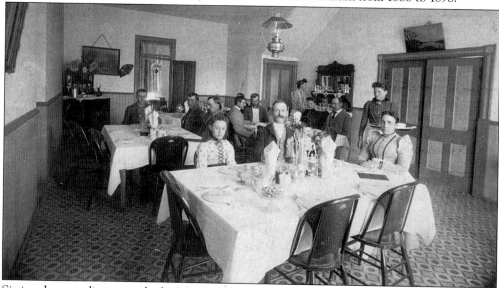

Sitting down to dinner inside the Meade Hotel are (at the first table) owner John S. Meade; his wife, Louisa (right), and their daughter Alberta ("Bertie"). The picture was taken around 1895. The servers are cousins Lena Kolb (Mrs. Carl Knoll), holding the tray, and Paulina Mueller (Mrs. Charles Meine), standing at the buffet.

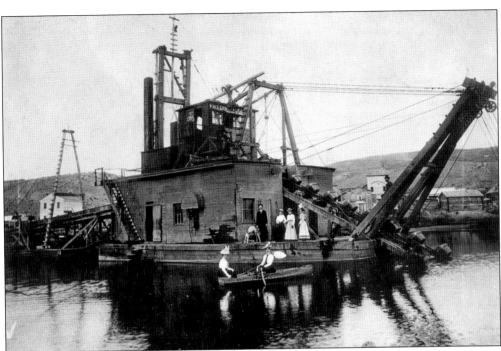

When the placer gold ran out, dredges were brought in to go after the deeper gravels. The *Fielding L. Graves* was the first dredge and was the first electric dredge in the United States. The powerhouse was on the bank fed by a water pipe coming down the mountain. She was launched on May 15, 1895, and operated for six months out of the year for the next seven years; her buckets could hold 5 cubic yards of gravel each.

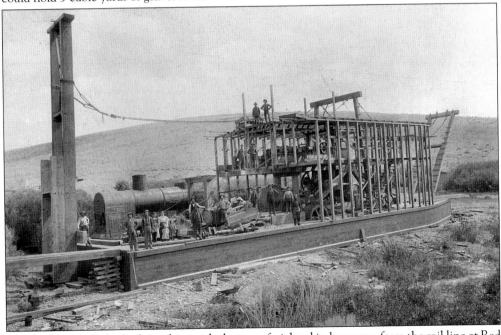

The dredges had to be built in place with the parts freighted in by wagon from the rail line at Red Rock. Most of the machinery was manufactured at the Bucyrus-Erie plant in Milwaukee.

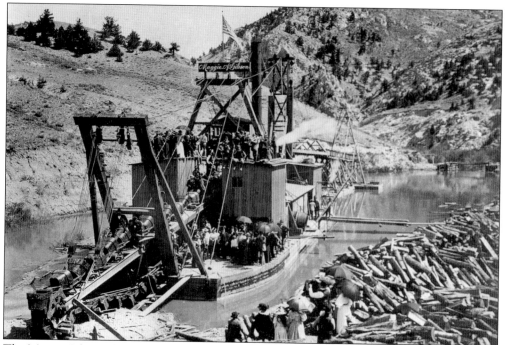

The *Maggie Gibson* was the second dredge built in Bannack. It was christened at Marysville just downstream from Bannack on May 23, 1897, by Maggie Gibson, wife of Archie Gibson, and it operated for two seasons before being moved over to Alder Gulch.

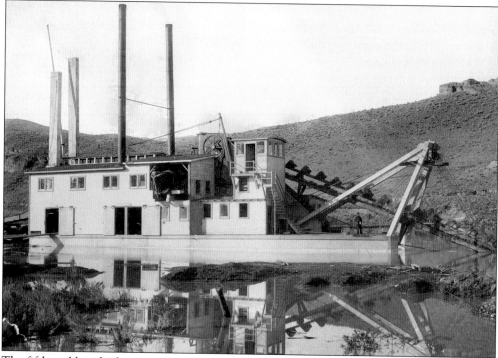

The fifth and last dredge to operate on Grasshopper Creek, at Spring Gulch near Bon Accord, below Bannack, is pictured here in 1899.

Joe Gauthier cleans out the sluice box of the *A. F. Graeter*. The gravel is run down this sluice, the heavy gold falls to the bottom while the rest of the gravel runs out, and the process is enhanced by putting mercury in the bottom that will catch the smaller gold pieces.

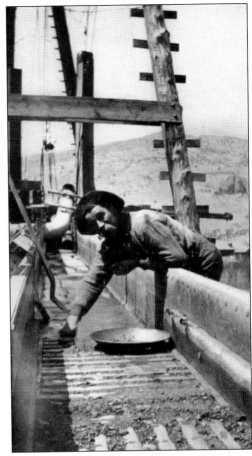

A view of Bannack shows the *A. F. Graeter* on the far left; parts of her are lying in Grasshopper Creek today.

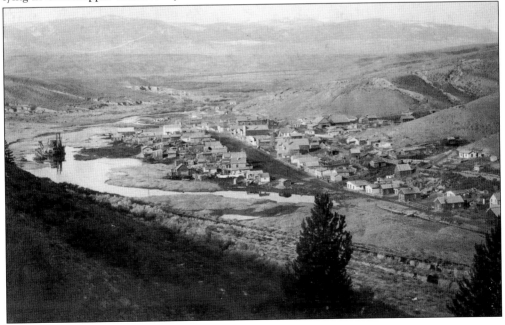

Argenta was established shortly after Bannack as a supplier of mine timbers and lumber for the fledgling city of Bannack. A sawmill was put up at the far end of Deadman's Bar, and lumber was hauled by way of Badger Pass. Argenta soon became a mining town as miners continued to spread out to look for more gold. Montana's first discovery of silver was found in 1864 between Argenta and Bannack. While the deposits proved to be rich, the ore had to be shipped out to be processed. The ore was freighted by oxen to trains in Omaha, then to New York by rail, and from there by ship to Swansea, Wales, for smelting, a voyage that consumed most of the profits.

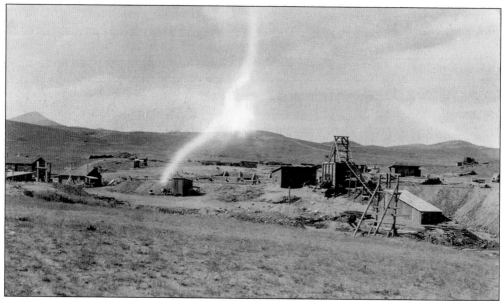

As other rich loads were uncovered, the need for a local smelter became apparent. In the fall of 1865, Montana's first smelter was built in Argenta.

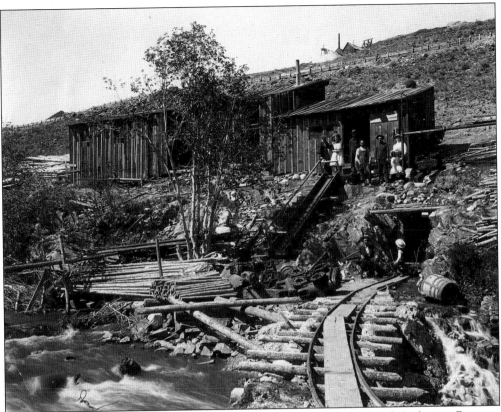

At the Iron Mountain mine, tunnel, and shop above Argenta, Tom and Catherine Ross are pictured by the stairs, and Jim McKey is in the doorway of the shop.

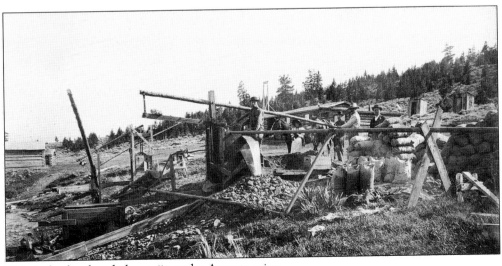

This is the first hand-plunge jig at the Argenta mine.

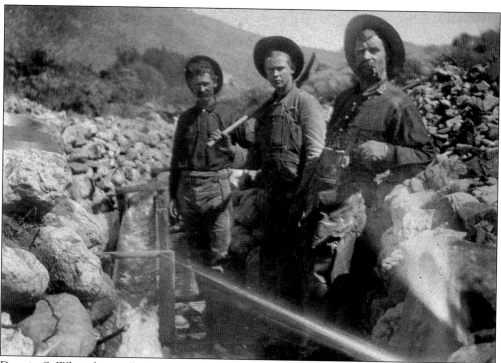

Darwin S. Whitethorne (left) poses with two unidentified men in 1905 on French Creek north of Argenta. Hydraulic mining continued on French Creek until the placer gold ran out.

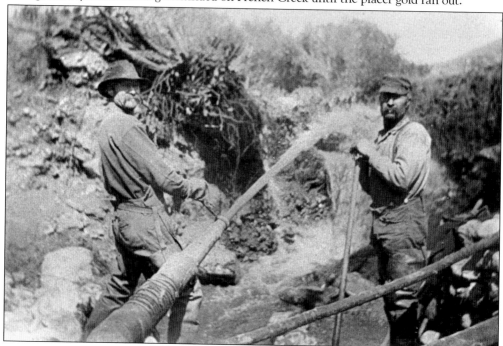

Hydraulic mining was used to increase the amount of gravel that could be worked in a day, as long as there was enough water to build pressure. By letting it drop, the water would do much of the work. Tons of topsoil were eventually washed downhill.

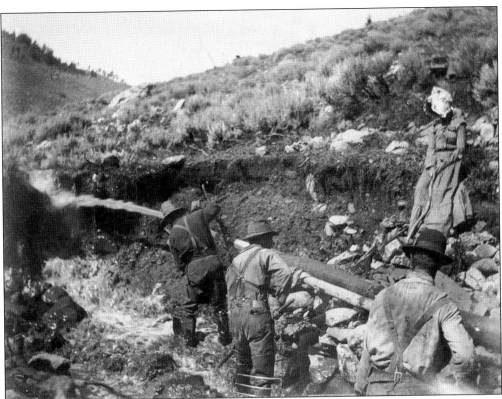

Pictured is a water cannon at the French Creek placer mines with a hydraulic nozzle. The man with the shovel is S. McIntosh. The picture was taken in 1907 by Hattie Whitehorne (Mrs. Darwin S. Whitehorne) on French Creek, near Argenta, Montana.

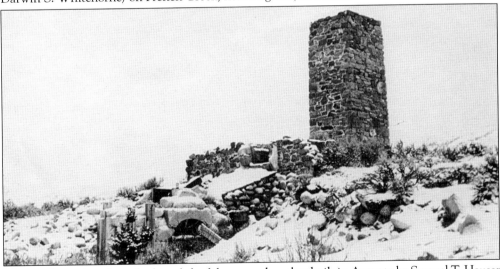

This smokestack is the only thing left of the second smelter built in Argenta by Samuel T. Hauser and James Stuart, with financial backing from the St. Louis and Montana Mining Company. Eventually, there were other smelters for a total of five during the silver boom of the 1870s and 1880s. Montana became the largest producer of silver in the United States in 1887, producing $15.5 million in silver.

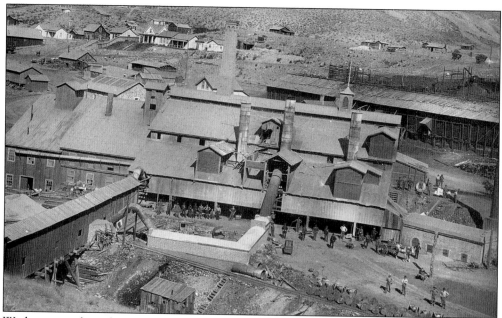

Workers pause from their assigned duties at the Hecla Consolidated Mining Company's smelter to stand for this photograph, taken about 1887. The smelter operated in this location from 1875 until August 1900. Charcoal was a major source of heat in the smelting operation and was produced at the charcoal camps in the nearby surrounding timbered areas. After being shipped to Glendale, it was stored in the charcoal bins across the road behind the smelter. The general manager's residence is seen just to the left of the smelter's large smokestack. (Courtesy of International Order of Glendale Research.)

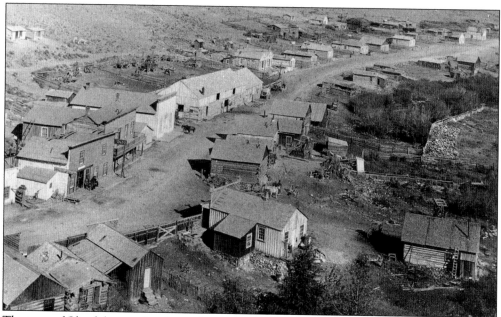

The town of Glendale served as the smelter location for the Hecla Consolidated Mining Company. It once had a population of 4,000, which made it larger than Dillon during the latter part of the 1800s.

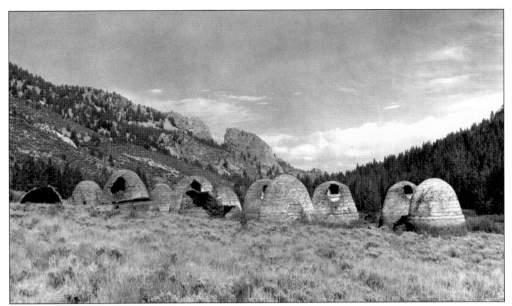

These large, strange-looking ovens were the kilns used to cook wood to make it into charcoal to be used in the smelter to melt down the ore. Charcoal burns hotter than wood (what it started out as) because it is mostly carbon. The smelter needs to get up to 2,000 degrees in order to liquefy the ore. The kilns are located close to the timber; each kiln used 35 cords of wood that were stacked to the ceiling, using the top door to finish loading. A fire was lit, and the holes around the bottom were used to regulate the temperature inside. It took two weeks to burn, yielding 35 bushels of charcoal.

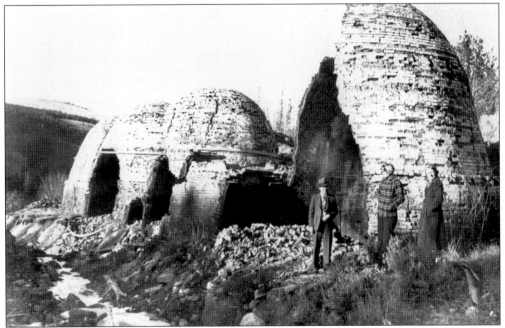

The skilled craftsmanship and the knowledge to operate the kilns came from Italian immigrants who had a long history of stone masonry and charcoal making. These six kilns, located on the bank of Trapper Creek, are near the town of Greenwood.

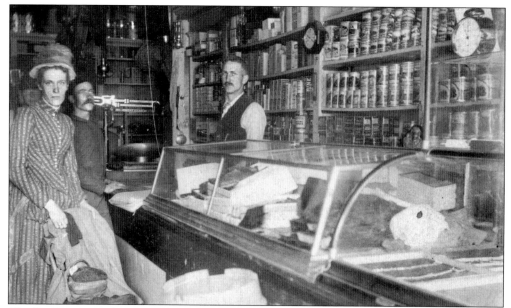

Charles Harvey tends to the needs of customers at the Glendale branch of the Hecla Mercantile and Banking Company. Charles and his brother, Edward, married sisters Alice and Julia Boetticher during a double ceremony in Indianapolis on September 21, 1887. The brides were nieces of Henry Knippenberg, and both men assumed store clerk roles after they arrived in the area. Ed worked for the branch operation at Lion City. (Courtesy of the Louise Harvey Jones Collection.)

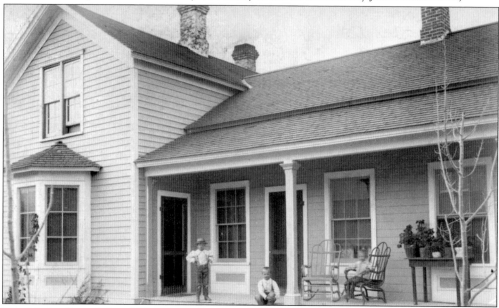

The Hecla Consolidated Mining Company provided housing for most of their management employees. This residence was home to the Charles Harvey family and was situated in the Highland Park addition to Glendale. The area was referred to by some as "Knob Hill." Many of the residential structures in and around Glendale were framed buildings, unlike those found in Hecla and Lion City, where trees were plentiful for log home construction. (Courtesy of the Louise Harvey Jones Collection.)

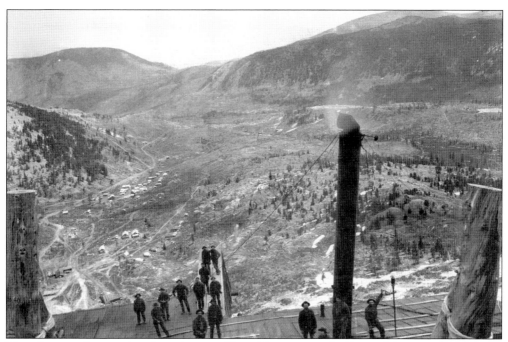

This photograph was taken from the top of Lion Mountain in the Bryant Mining District. In the foreground is the town of Hecla with Lion City just beyond, near the left center of the image. Trapper City is located in the background just to the left of the top of the smokestack. Since most of the mining activity occurred on Lion Mountain, the population center shifted to the base of the mountain. (Courtesy of the Louise Harvey Jones Collection.)

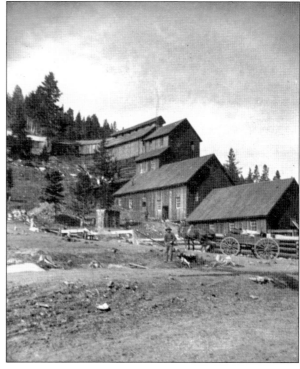

One year after assuming the role of general manager of the Hecla Consolidated Mining Company, Henry Knippenberg convinced the company stockholders that a mill was needed to bring 50,000 tons of second-class ores to market. This concentrator mill, built three miles below the mines, was named Greenwood. Company offices were located there, but saloons and other such businesses not considered essential by Knippenberg were banned from this area. (Courtesy of the Louise Harvey Jones Collection.)

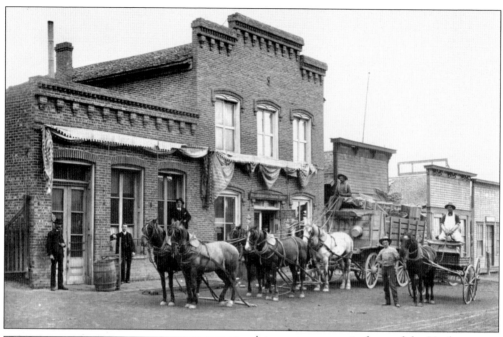

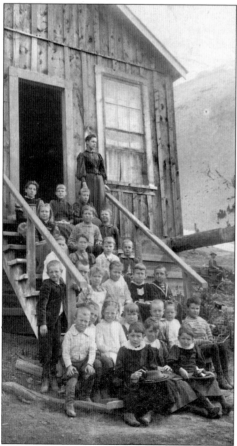

A teamster pauses in front of the Hecla Mercantile and Banking Company (HMBC) on upper Main Street in Glendale, while Otto Boetticher stands next to the single horse pulling a cart. The two-story brick building was built to house the general mercantile of Thomas and Armstrong in 1877. The bank portion, to the left, was added later. In April 1886, the HMBC was incorporated after merging the banking firm of N. Armstrong and Company and Armstrong and Lossee's mercantile, both of Glendale, along with Kappes Mercantile at Lion City and the Gaffney and Purdum store of Melrose. (Courtesy of the Louise Harvey Jones Collection.)

The school teacher was Eva Strausberger, from Butte. From left to right are (first row) Bette Todd, Lilly Hull, and ? Todd; (second row) A. G. Terry, three unidentified, Harvey Smith, unidentified, and Tony Quilici; (third row) Frank Hull, Harry Smith, Myrtle Terry (Mrs. R. A. Blackely), two unidentified, and Gill Quilici; (fourth row) unidentified, Pearl Terry, unidentified, and Othol McMasters; (fifth row) Lena Quilici, Alfred Nixholm, and Jim Todd; (sixth row) Celesta Quilici, Ida Nixholm, and Lena Nixholm. (Courtesy of the Louise Harvey Jones Collection.)

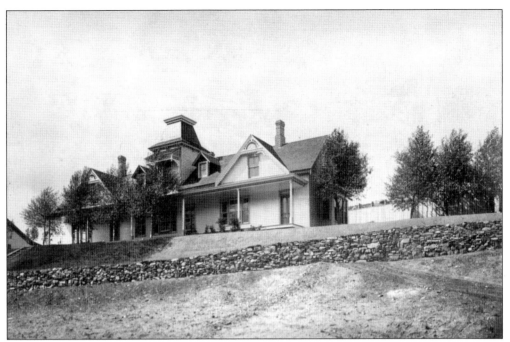

This home was provided to Henry and Alice Knippenberg and their family at Glendale. It was described as a 14-room two-story affair. It was furnished with many amenities, such as a cistern up on the hill, which provided a gravitational flow of water to the home for all their needs, including a fire-suppression system. The building was demolished in 1957 to make room for a modern home. (Courtesy of the Louise Harvey Jones Collection.)

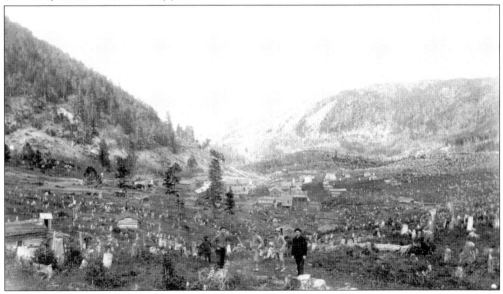

Looking down the valley basin from near the base of Lion Mountain, this photograph shows the remains from the massive timber cutting by the mining industry for rail ties, mine timbers, charcoal, and fuel. The clear cutting allowed massive snow avalanches to come down on the towns of Hecla and Lion City, resulting in deaths and damage. (Courtesy of the Louise Harvey Jones Collection.)

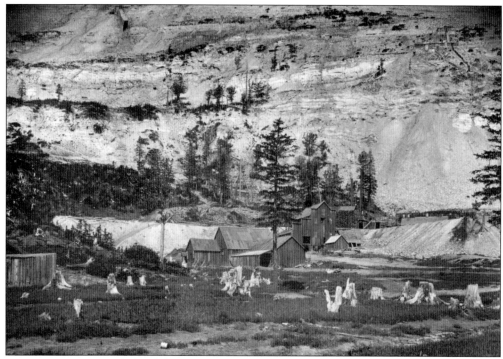

Lion Mountain, rising behind the buildings, is dotted with mines. It may look steep, but that did not stop the miners.

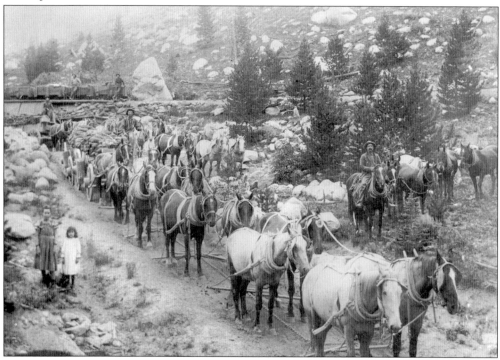

Horses haul ore from the mines down to the smelter for final processing. The rich ore was crushed before it was hauled to the smelter in Glendale.

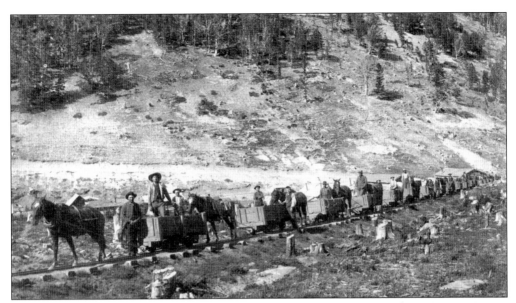

Ore extracted from the company mines was taken down to the Greenwood concentrator via ore cars such as these. When loaded, they were ridden down the tram with brakemen, hopefully maintaining reasonable speeds for a safe arrival. After being emptied, the cars were pulled back up to the mine portals with horses. The labor intensity of the operation is evident in this photograph, in both man and horse power.

This picture, taken inside the smelter, shows where the metal is extracted after being heated to no less than 2,000 degrees. It required large amounts of charcoal to get this high temperature.

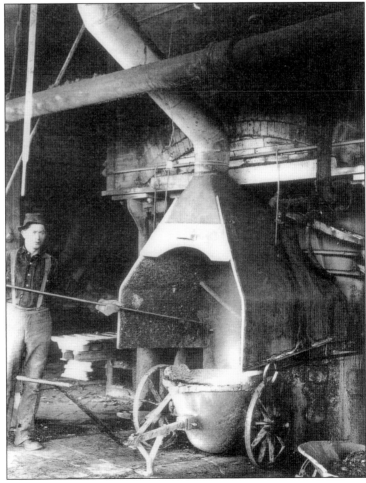

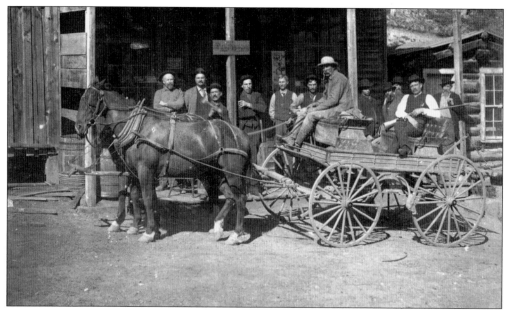

This wagon was not used for freight; it had springs for a more comfortable ride, so it was used for passengers only. Note the nice leather seat. Since the rider is armed, they may have been hauling bars of gold and silver to the bank.

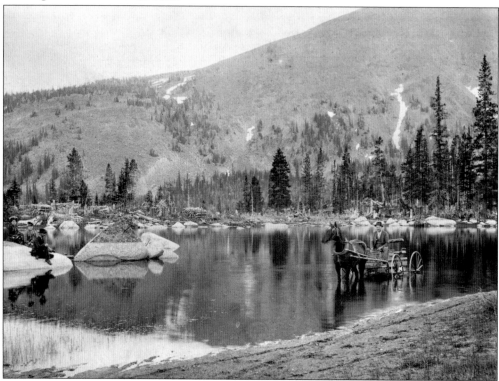

Wagon wheels are made of wood, and in the dry Montana climate, they dry out. It was common to soak or otherwise wet down the wheels. Here the driver uses Trapper Lake at the headwaters of Trapper Creek.

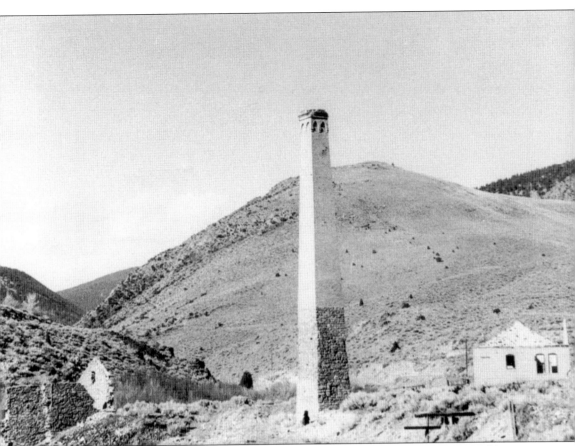

During its heyday, Glendale was a flourishing town of 1,500 to 1,800 inhabitants. In addition to the smelting works, there was a waterworks system and fire protection, furnished by the company. There was a church and a school house, presided over by John Gannon, who later became state superintendent of education. There were 3 hotels, 2 dry goods stores, 7 grocery stores, and 13 saloons. There was a bank, two drugstores, two shoe stores, a fine jewelry store, several confectioneries, a brewery, a photography gallery, a weekly newspaper, and a lumberyard. Besides Glendale, the Hecla Consolidated Mining Company employed—at its mines at Lion Mountain near Lion City, its iron mines in Soap Gulch, its concentrator at Greenwood, and at its Glendale smelter—close to 600 men and, in addition, a large number of Italian charcoal burners, who produced the fuel for the smelting furnaces until the coming of the railroad made it possible to bring in coke from Pennsylvania. The furnaces produced bullion until 1900, when it became more profitable to ship the ore than to smelt it. Four years later, the company's operations came to a close, and the smelter was dismantled, leaving only the smokestack.

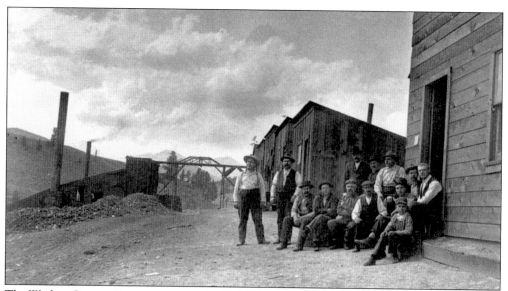

The Washoe Copper Company operated in Farlin Gulch on Birch Creek, north and west of Dillon. This picture was taken above the smelter in 1903. The next three pictures are taken below or level with the smelter. The town of Farlin and the Indian Queen Mine were started by William and O. D. Farlin, who located rich lodes of silver, copper, and iron in 1875. The first smelter in Glendale was supplied by Farlin with iron ore, which was used for flux. The mine flourished for three years, was then sold in 1904, and reopened with its own smelter that ran for a year. The town at one time had a general store, school, and saloon for the several hundred people that were living there. An official post office operated from 1905 to 1906; Gertrude Black was the postmaster.

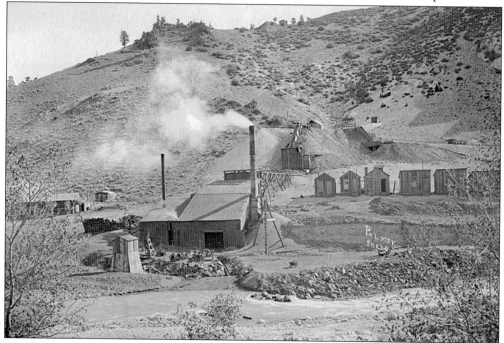

This series of three photographs is of the Indian Queen Mine in Farlin on Birch Creek. The smelter was built in 1905. The creek is in the foreground flowing from left to right.

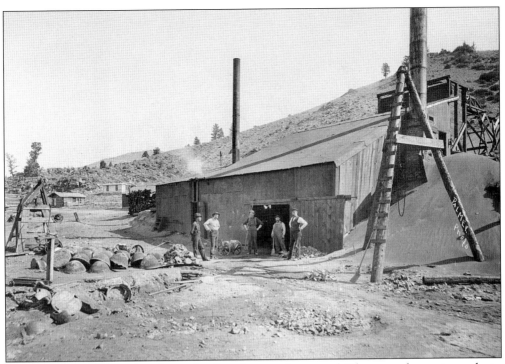

A closer look at the smelter shows the slag plugs on the ground. These are the waste products, and the good stuff has already been extracted.

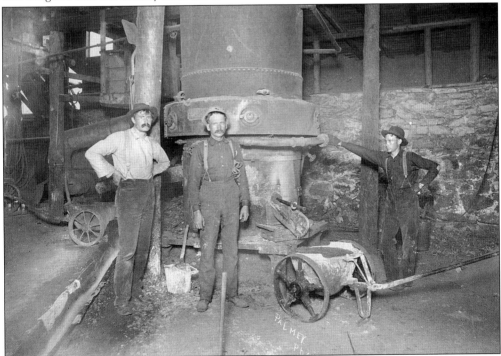

Inside the smelter, this image shows how the slag comes out at the bottom and is poured into the pot with wheels to be hauled away. Heavy gloves are needed for this kind of work.

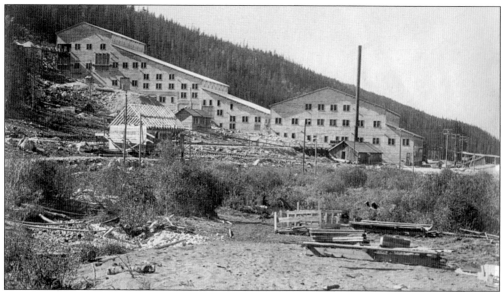

The mill at Coolidge, located between Elkhorn Hot Springs and Wise River, was part of a grand mining adventure by William R. Allen. In 1913, Allen formed the Boston Mining Company, and by the end of the year, a good road from Wise River to the mine was in place. In 1919, a narrow-gauge railroad from Divide to Coolidge was completed to carry the ore to the Union Pacific Railroad at Divide. The town started in 1914 and reached a population of 250, but by 1932, the post office was closed, and five years later, the school was closed. Today Coolidge is a ghost town and a reminder of the county's mining heritage.

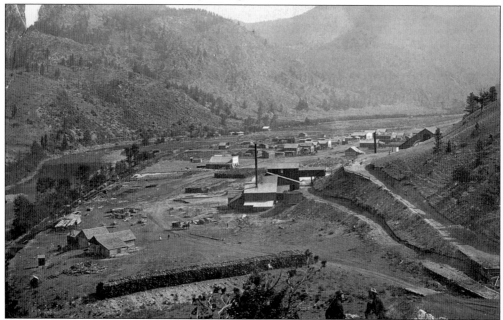

Dewey Flats was named for David Dewey, an early rancher. The original town site was south of the Big Hole River. Dewey, along with George Pettingill, Jerry Grotevent, and Jack Rafter, discovered rich prospects in the Portshill District in 1869. Today it is the turning point for curious visitors looking for Quartz Hill and Vipond Park mining areas.

Three

TRAVELERS, TRAILS, AND TRANSPORTATION

The first people came into southwest Montana about 12,000 years ago and started footpaths along the most efficient routes. Native Americans acquired the horse around 1700 and widened the shallow trails. Lewis and Clark came in 1805 by paddling and poling upstream, and then trading for horses. The mountain men followed with their pack strings, and in 1841, Father DeSmet left the Oregon Trail at Fort Hall, Idaho, and headed north on the Montana Trail to Beaverhead Valley. With several carts and a wagon, he passed through on his way to the Bitterroot Valley. Trade into Montana came from the south by means of pack trains, and in 1852, an enterprising trapper and trader drove an ox team into the Beaverhead Valley. Soon others followed. Freighters developed their own method of hauling, which differed from the pioneer wagons on the emigrant trail. Freight wagons were big, with wider wheels, often 4 inches wide with a ½-inch-thick steel band. A freight outfit would consist of three wagons hitched together, with each one smaller than the one in front, carrying 5,000 to 6,000 pounds of freight. They were pulled by 12 to 16 horses, oxen, or mules. Stagecoaches eventually followed the freighters and could travel at a faster pace to carry passengers and mail; however, unlike the freighter, stages required stations along the route to change horses and rest and feed the travelers. With the coming of the railroad, the long-haul freighting business declined, but the short-haul freighters were still needed to forward freight where the railroads could not reach. There were four forwarding houses in Dillon that handled passengers as well as freight. The ancient foot trails that became horse paths and wagon and stage roads were eventually paved. A person walks about two miles per hour (as do oxen and mules when pulling a load), horses travel three to four miles per hour, and stagecoaches moved seven to eight miles per hour. Today cars run along the same trails at 10 times that speed.

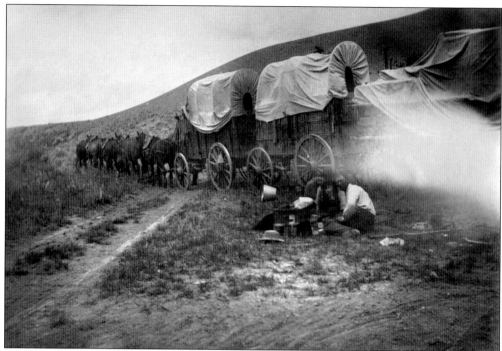

The long-haul freighter was the one that opened the way for the supply line of freight to sustain those living in the territory. These hardy men would connect three wagons to teams of horses, oxen, or mules and travel 500 miles north at 12 to 15 miles a day, taking more than a month to reach their destinations.

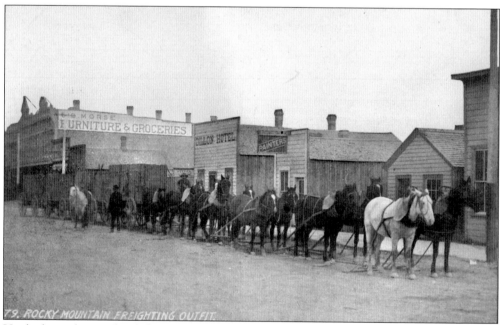

Hooked together in this fashion, one team (in this case, with 12 horses) can haul 6 to 8 tons of freight.

Stagecoaches carried people, mail, money, gold, and smaller items, while traveling at three times the speed of a freighter.

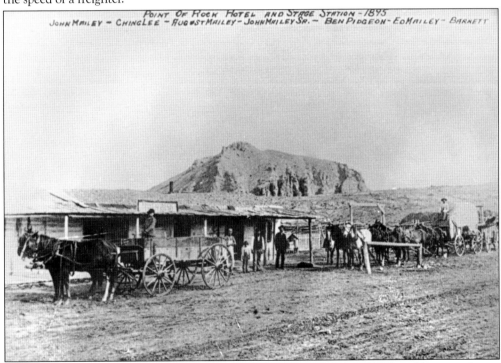

POINT OF ROCK HOTEL AND STAGE STATION - 1895
JOHN MAILEY - CHINGLEE - AUGUST MAILEY - JOHN MAILEY SR. - BEN PIDGEON - ED MAILEY - BARNETT

Shown here are the Beaverhead Rock or Point of Rocks stage station, hotel, and beanery. Stages required stations all along the route, usually about every 15 miles, to change out horses and let the passengers out to stretch. This station started in the 1860s and ran into the late 1880s. The station was operated for years by Annie Martin, then Sim Estes, and later Ben Pidgeon. Pictured from left to right are John Mailey, Chinglee, August Mailey, John Mailey Sr., Ben Pidgeon, Ed Mailey (on horse), and Barnett.

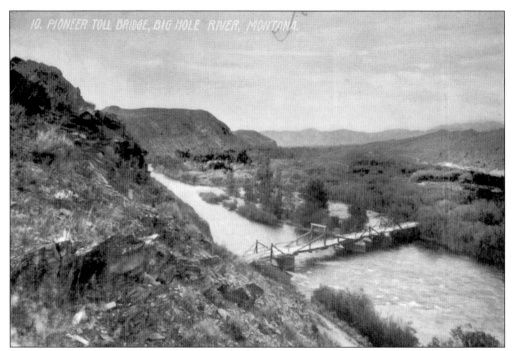

Browne's Bridge was built in 1867 across the Big Hole River and was operated as a toll bridge to cover the expenses for construction and maintenance. Acquired by Joe A. Browne in 1870, he operated it until his death in 1906. Then his son and daughter, Joe Jr. and Fanny, ran it until 1911, when it was turned over to the county as a non-pay bridge. It was replaced in 1914.

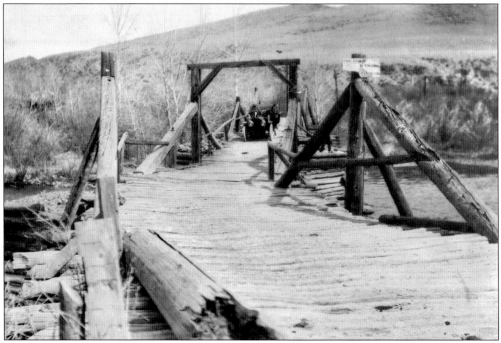

Browne's Bridge over the Big Hole River was the last operating toll bridge in Montana. The king-post trusses and rock crib piers were typical of early bridge structures in the territory.

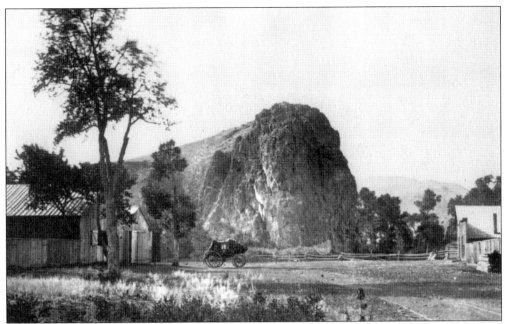

Barrett's Stage Station was originally called Sturgis after William Sturgis and James Ryan were awarded the contract to construct the Great Beaverhead Wagon Road through the canyon by the territorial legislature. This saved miles off the road to Salt Lake, Butte, and Helena. In 1866, the road opened, and a tollhouse was constructed, along with a stage station. Mrs. Sturgis was well known for the meals she served to the passengers. The post office opened in 1868 with Sturgis as the postmaster. Ryan bought out Sturgis, and his cousin Michael B. Henneberry became his new partner in 1869. In 1870, Henneberry bought out Ryan. In 1875, Thomas M. Barrett bought out Henneberry and ran the stage station until the railroad came in 1880 and Tom moved to Dillon. The cliff in the background was called Rattlesnake Cliffs by Lewis and Clark.

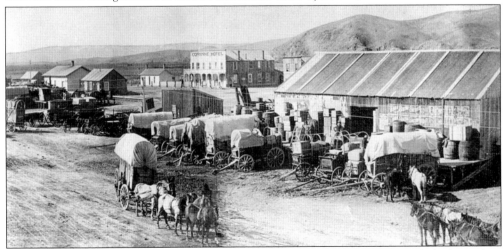

When the railroad reached Dillon in 1880, the town became a major shipping hub, forwarding freight to the towns beyond the tracks. There were four major forwarding companies in Dillon, which handled passengers as well as freight. These were Sebree, Ferris, and Holt; W. M. Rank; J. B. Meredith; and John W. Lovell. Later Rank sold to B. F. White, who eventually became Dillon's first mayor.

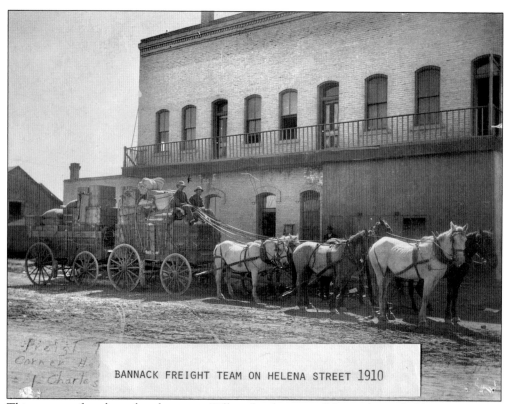

BANNACK FREIGHT TEAM ON HELENA STREET 1910

Thirty years after the railroad came to Dillon, freight was still being forwarded by wagon. This freight wagon at the corner of Helena and Montana Streets is heading out to Bannack in 1910; this building today is the Club Bar.

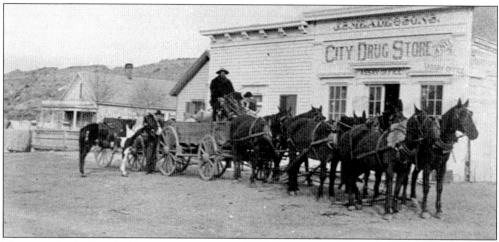

The short hauler handled business between towns and ranches. The trucking industry goes back to the beginning of this country.

50

Four

THE COMING OF THE

RAILROAD

The transportation of supplies into Montana in the 1860s was slow and difficult as well as seasonal: winter snows would stop all freighting until spring. Starting in Corinne, Utah, a typical freighter could haul 6 to 8 tons using three wagons hooked together and pulled by 12 to 14 mules or oxen. The wagons could only travel 12 to 15 miles a day with 500 miles of nothing but a rough trail to reach Montana. By 1863, a freight and stage line was established between Salt Lake City, Bannack, and Virginia City. The transcontinental railroad was completed in 1869, connecting the country east and west. It was a matter of time before other lines were added on. Montana was so sparsely populated that it was not practical or profitable. Yet the lack of good transportation was one of the obstacles to the settlement of the area. Eventually, it was the mining activity in Montana that helped to stimulate the need for rail service and the money that could be made transporting supplies and equipment in and the valuable ore out. It was obvious the railroad was the way to provide fast and inexpensive transportation. When gold was discovered in 1862, the value of Montana to the Union was becoming increasingly evident. Montana's commerce amounted to $2 million in gold a month. Between 1862 and 1867, Montana had produced $75 million in gold and in 1867 alone $16 million to add to the money in circulation. In 1871, small sections of the narrow-gauge Utah Northern Railroad started north; however, during the next five years, it struggled with financial problems. Then, in 1877, with Union Pacific backing, the newly incorporated Utah and Northern Railroad Company continued north from Utah to the mining towns in southwest Montana. On March 9, 1880, the Utah and Northern reached the territory border, the first railroad to enter Montana. The coming of the railroad 18 years after the discovery of gold marked a fresh supply of capital and commerce for Beaverhead County, as well as the entire economy of the territory.

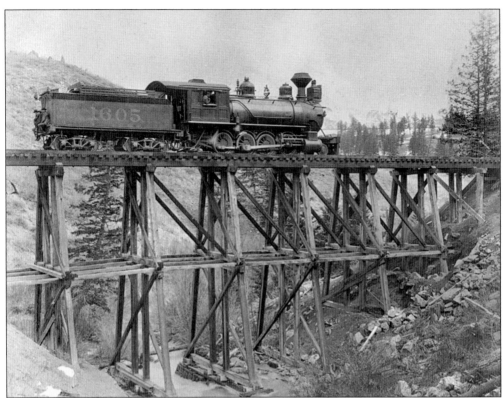

Crossing the trestle at High Bridge in Beaver Canyon when returning from Monida in 1890, this Oregon Short Line and Utah Northern standard-gauge 10-wheeler just helped a train up the long grade over the Monida pass. Note the brakemen riding on the back of the tender.

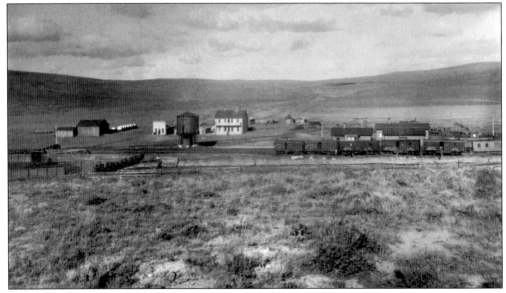

An early picture of Monida shows the water tank, hotel, and depot. The white canvas–topped wagons on the left are part of the Monida–Yellowstone Stage Line, which carried tourists 70 miles through the Centennial Valley to Yellowstone National Park from 1898 to 1908.

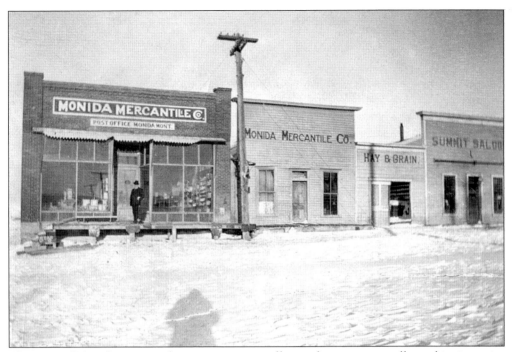

The town of Monida grew as it became a jumping-off point for tourists as well as a shipping point for sheep and cattle trailed out of the Centennial Valley. Bert Paul started the Monida Mercantile in 1893 and owned most of the town at one time.

Yellowstone became a national park in 1872. The Centennial Valley was named by Rachel Orr, the wife of William Orr, who in partnership with Philip H. Poindexter developed the P and O ranch, now called the Matador. The P and O ran cattle in the valley before it was homesteaded. This picture shows the nice coaches that were used to carry tourists through the Centennial Valley to the town of West Yellowstone at the park's entrance. The 70-mile trip was completed in a day, with the changing of horses every 15 miles. The Y-P stage, as it was known, was started by F. Jay Haynes, a well-known Yellowstone photographer, and a man named Humphreys, who was an experienced stage manager.

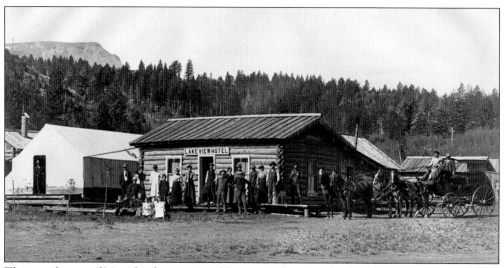

Thirty miles out of Monida, the stage would stop at Lakeview, which had a hotel, a general store, a saloon, and a chance for passengers to stretch their legs.

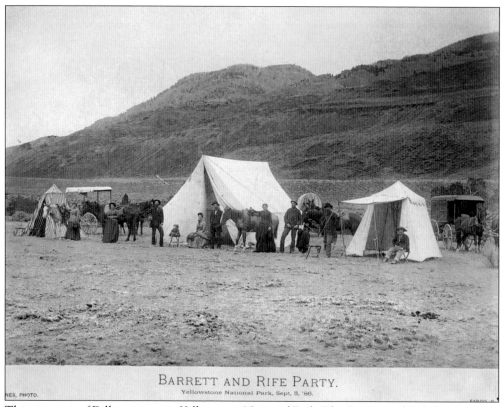

BARRETT AND RIFE PARTY.
Yellowstone National Park, Sept. 5, '86.

This picture is of Dillon visitors in Yellowstone National Park. The Barrett and Rife families were photographed in 1886 by park photographer F. Jay Haynes.

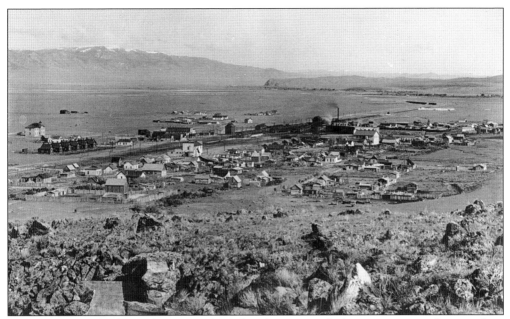

Fifteen miles north of Monida is Lima; the railroad maintained a large presence in the town from 1880 to 1952, affecting the economy and population. On the far left is the two-story school. The dark, curved building to the right of center is the 12-stall engine house with a turntable in front. Employment was good until around 1952, when the Union Pacific switched to diesel-electric engines, downsized, and closed the roundhouse; 53 jobs were lost.

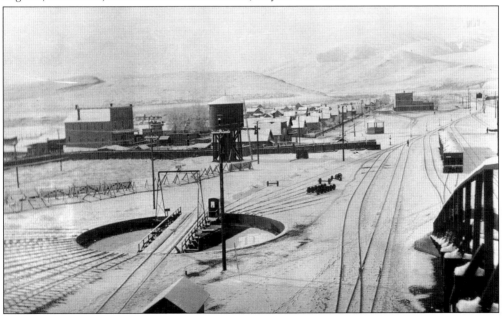

This picture was taken from the top of the coal chute looking south with the 70-foot turntable in the foreground. The 12 sets of tracks in the lower left corner go to a 12-stall engine house and machine shop. The three-story building on the left is the Merrell Hotel. The large building in the upper right is the Club House, which was built by the railroad to house and feed crews. The Peat Hotel and Saloon are out of the picture on the right.

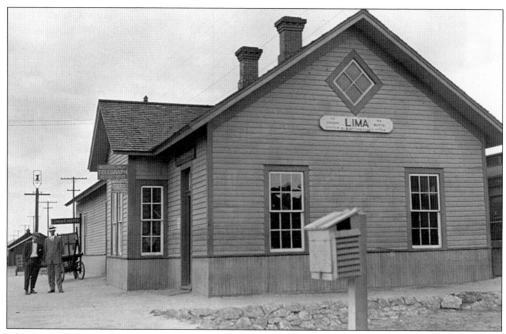

The Lima depot and telegraph office are pictured here around 1930.

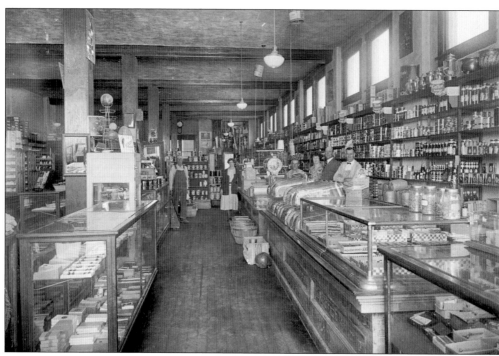

Frank Merrell opened this store in Lima in 1913 and operated it until 1939, when he moved to Idaho Falls and turned the business over to his sons, Marion, Max, and Winston. Max and Winston operated the business until 1976. The man on the right is Joe Mulkey; the second man from the right is Frank Merrell.

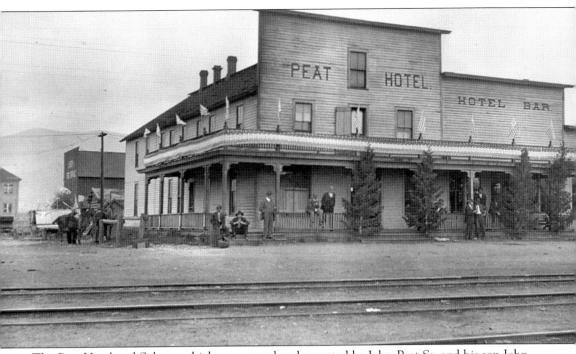

The Peat Hotel and Saloon, which was owned and operated by John Peat Sr. and his son John A. Peat, were popular spots during the busy railroad years.

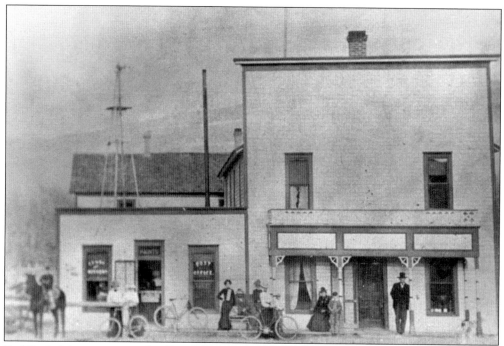

Red Rock, Montana, is north of Lima. On the left is the mercantile and post office; on the right is the C-D Hotel, which was owned by brothers-in-law Alph Decker and J. W. Scott, who came to the area in 1880.

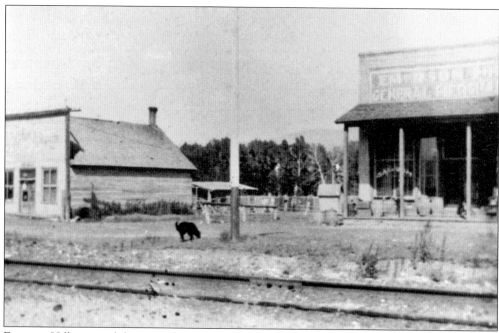

Emerson Hill operated the general mercantile and implements business in Red Rock until moving to Salmon, Idaho, in 1907.

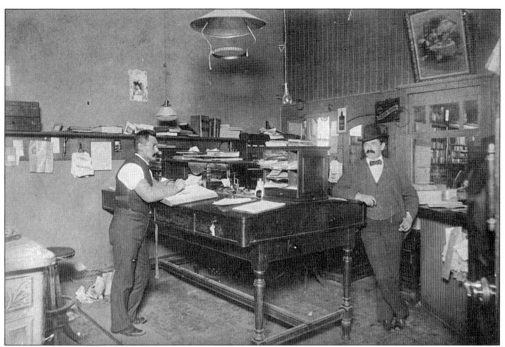

The Red Rock Railroad depot for the Oregon Short Line would eventually move to Armstead.

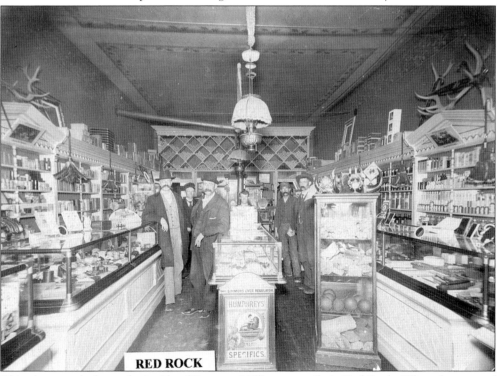

This photograph shows the inside of Emerson Hill's mercantile in Red Rock. When the town of Armstead was started five miles to the north, all the businessmen moved to the new community, leaving the town of Red Rock to fade into history.

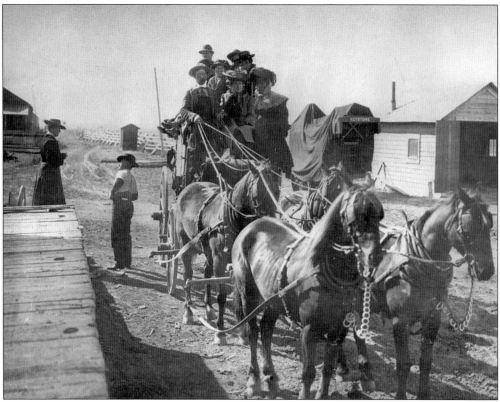

The Red Rock–to-Salmon stage was owned and operated by Fred Vogler. This picture was taken before 1909 while the stage was still operating out of Red Rock.

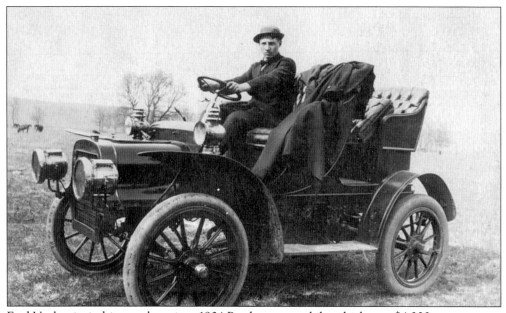

Fred Vogler sits in his new, luxurious 1904 Peerless automobile, which cost $4,000.

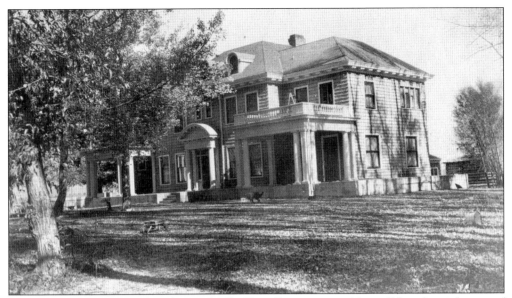

The Red Rock home of Edward B. and Effie Tong Roe is pictured here. Edward was the son of William and Margaret (Shineberger) Roe, pioneers of Bannack and Red Rock. Edward inherited the Shineberger ranch when his uncle Joe Shineberger died in 1908. In 1913, the large family home was built on the ranch to house a family that grew to five children over a span of 10 years. The building was later moved to the Western Montana College campus.

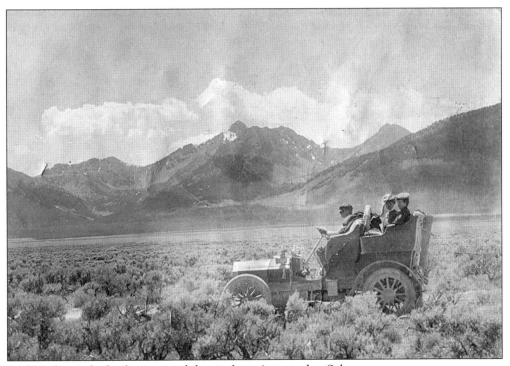

Fred Vogler made the first automobile trip from Armstead to Salmon.

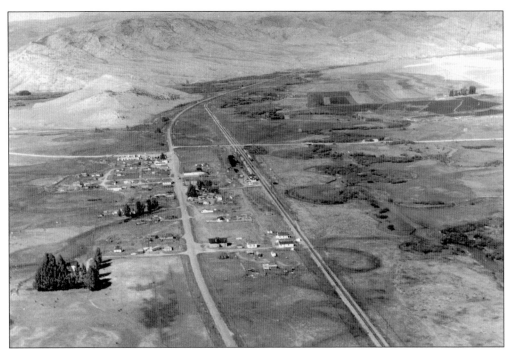

This aerial picture of Armstead shows its location alongside the railroad (on the right). The town takes its name from Harry Armstead, who owned and operated the Silver Fissure Mining Company at Polaris. Harry needed to get his ore to the Oregon Short Line Railroad, located 50 miles away, so he secured the land along the tracks and started the town, naming it after himself.

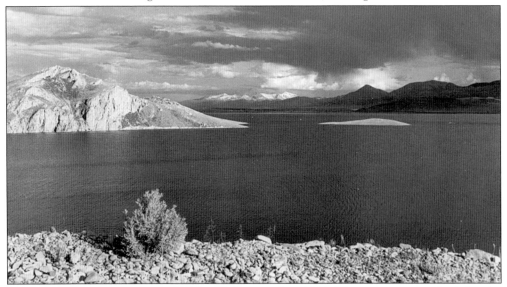

The Clark Canyon Reservoir inundated Armstead in 1964. The reservoir was built by the Bureau of Reclamation for flood control and irrigation. The waters stored behind the earth-filled dam provide recreation and fishing year-round. The water is released for irrigation during the short growing season to the farmers and ranchers downstream in the Beaverhead Valley. The mountain in the open plain to the north and west of the town is now the large island on the left of the picture.

Harry Armstead, owner of the Silver Fissure Mining Company, was from back east and had big plans, but the cost of transporting his ore soon put him out of business. By 1909, Armstead left Montana. The town he started and named after himself thrived from 1907 to 1962.

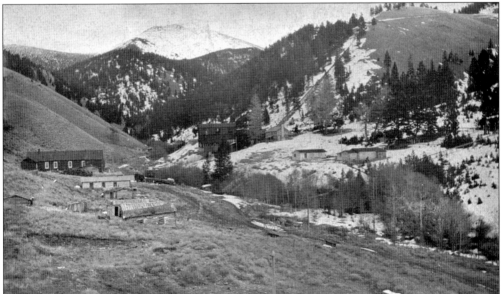

This is the site of the Polaris mine and the Silver Fissure Mining Company, where the ore being hauled to Armstead was mined.

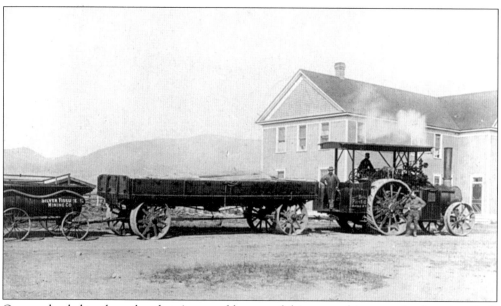

Ore was hauled to the railroad at Armstead by way of this steam-driven overland engine. Each train (not on tracks) consisted of one engine, one water wagon, and three ore wagons.

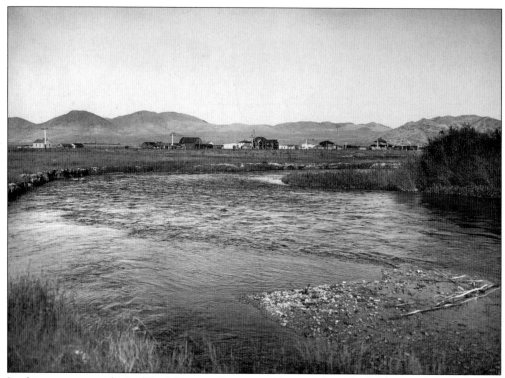

Looking west across the Red Rock River at the town of Armstead, on the left is the school, the three-story building in the center is the hotel, and on the right is the Oregon Short Line station.

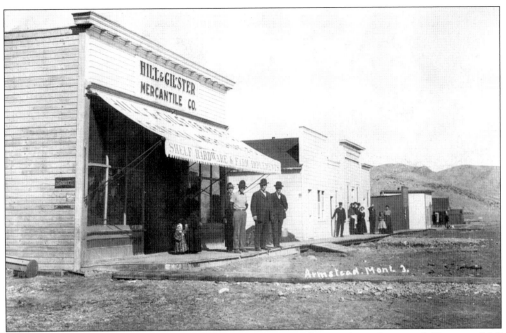

Most of the businesses from Red Rock moved the five miles north to Armstead. Emerson Hill had a thriving business in Red Rock, and shortly after moving up to Armstead, Emerson, his wife, and their daughter moved to Salmon, Idaho.

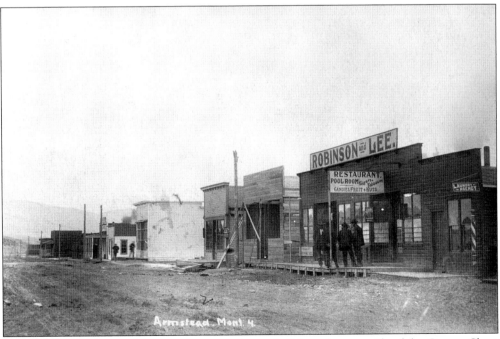

In 1907, the new town of Armstead was starting to build on the west side of the Oregon Short Line tracks. There were rumors of a new rail line that would also connect the town with Salmon, Idaho.

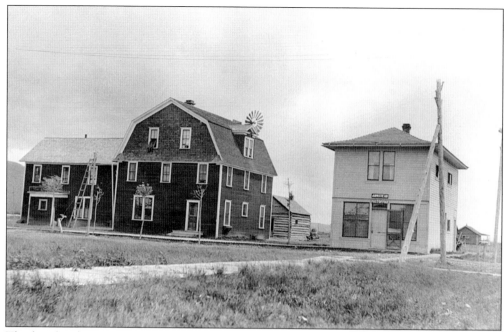

This hotel and post office in Armstead, Montana, shown in 1918, are now under the waters of the Clark Canyon Reservoir. The hotel did a brisk business when passengers came in on the Union Pacific Railroad on the afternoon train and then had to wait overnight for the morning train of the Gilmore and Pittsburg Railroad to Leadore and Salmon, Idaho.

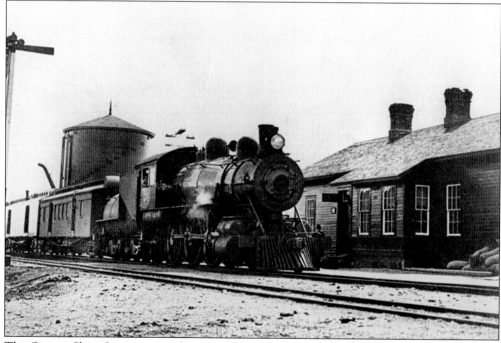

The Oregon Short Line stops at the original depot at Armstead, built in 1908. The agent was also kept busy running the telegraph since it handled all the Western Union business for the Salmon River country as well as locally.

This 1914 scene shows a passenger train stopped at the new Armstead depot. The Oregon Short Line connected here with the Gilmore and Pittsburg Railroad from the time it was opened in 1910 until the line was shut down in 1939.

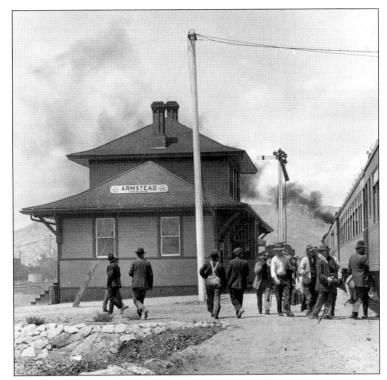

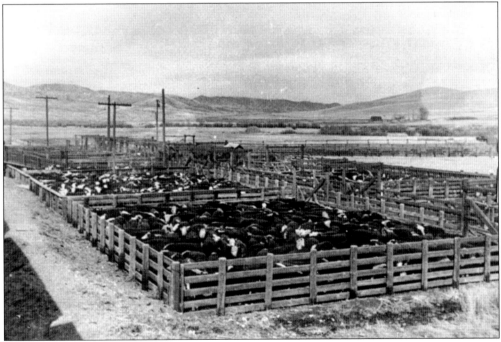

In 1922, the railroad added more stockyards, and in 1930, they were doubled with two double-deck loading chutes. The stockyards were expanded again in 1948 and were still in use in 1951. At one time, Armstead was the largest shipping point of livestock on the Union Pacific since it was handling cattle from the Lemhi Valley in Idaho as well as the surrounding area.

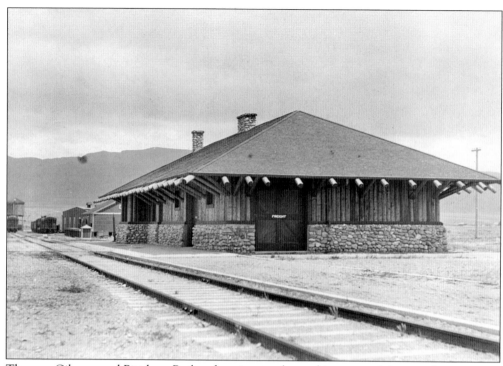

The new Gilmore and Pittsburg Railroad station was located just west of Armstead.

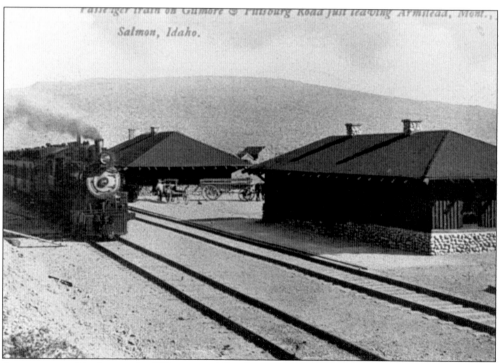

A passenger train leaves the Gilmore and Pittsburg station at Armstead, Montana, headed for Salmon, Idaho.

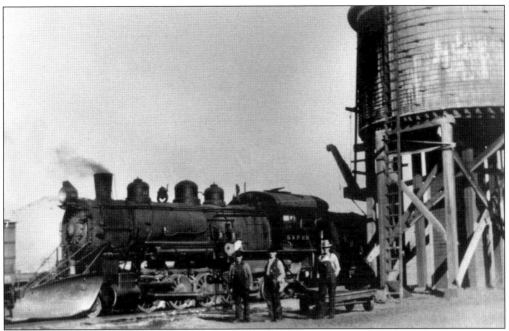

A Gilmore and Pittsburg train is stopped below the water tower in Armstead. From left to right are Andy Burman, conductor; Jack Harpe, engineer; and Dick Given, fireman. Note the snowplow is still attached to the front of the train.

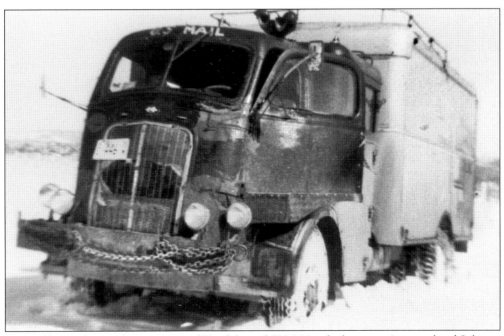

The Miller Brothers 1958 International Truck logged 500,000 miles between Armstead and Salmon, Idaho, carrying mail and freight. The drivers were "Shorty" Leon Howard and Robert Connie "R. C." Gravely. The construction of the Clark Canyon Dam put an end to their long service.

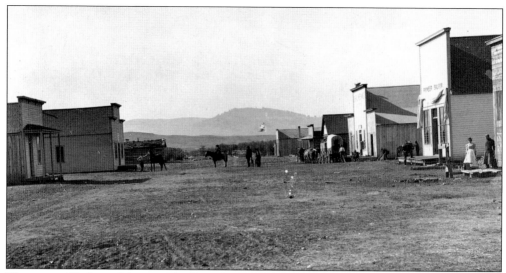

This view of Jackson, Montana, looking south, includes Martin C. Jackson, on a horse; Charlie Bryant, standing at the back of wagon; Bill Kinney, seated; Charlie Major, on the saloon step; and Al McDonald, who was a blacksmith (far right).

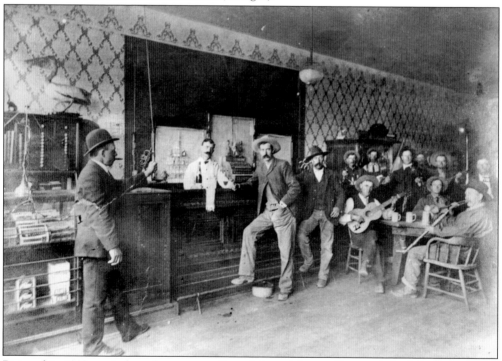

Pictured in 1903 are Jackson bar patrons. From left to right are (first row) Rock Perry, with the fishing pole, who was the local barber; Charlie Lloyd, who was the bartender; Tom Pope; Chris Deitchman; Harry Melvin with the guitar, who ran poker games and drove the stage for the Lapham brothers; Jim Milne, who was a ranch worker; and Gus Wenger; (second row) Charley Berry, who helped Harry Lapham build the hotel; Dick Nedrow, who ran the Jackson meat market; Sid Hawk, who killed Owen Ellis in this bar; unidentified; Clarence Brown, who ran a store in Jackson; and Frank Carrier, a rancher who once used $100 bills to play poker.

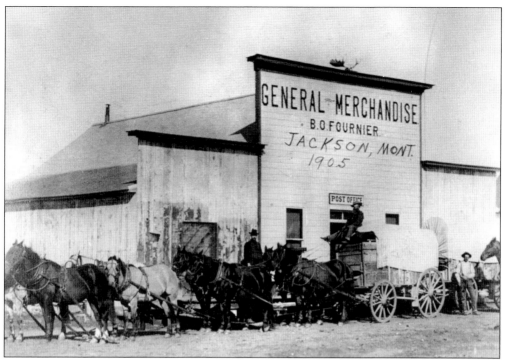

The B. O. Fournier Store in Jackson, Montana, is pictured with Fournier's freight outfit in front. Hiram Lapham and his son Harry also ran a freight line out of Jackson.

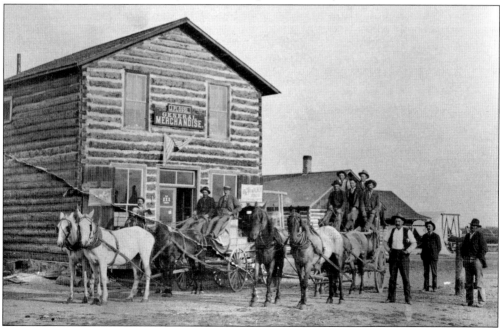

Wisdom was a stage station in 1896 when J. P. Lossl bought the Stage Line Hotel and the old store. When the town site was surveyed, he purchased lots on Riverside Street and built a new stage station and store. He owned two stores; one had groceries and clothing, and the other sold hardware and farm machinery.

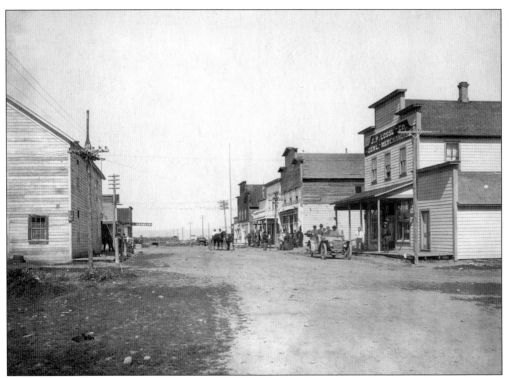

J. P. Lossl's new store (right) in Wisdom is pictured around 1910.

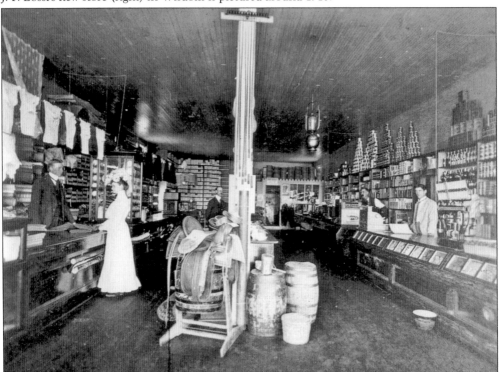

This view is inside Lossl's store in the early 1900s.

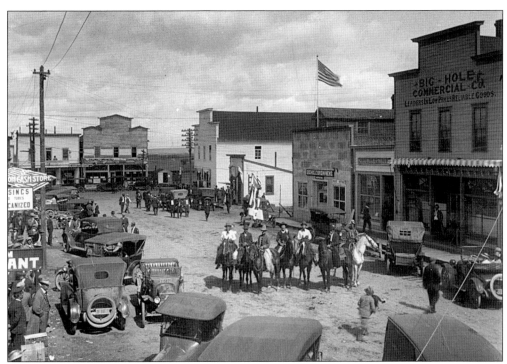

Behind these riders in Wisdom in 1923 is the *Big Hole Basin News*, which operated from 1923 to 1925. Next to it is the State Bank of Wisdom.

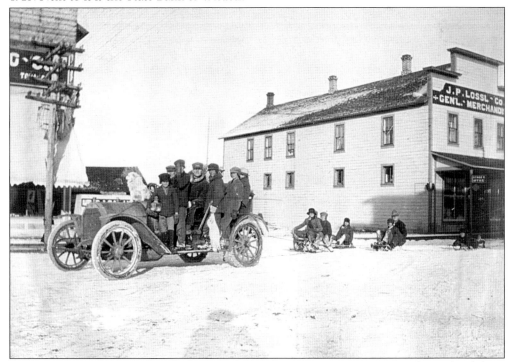

In Wisdom in the early 1900s, everyone was out for some winter recreation. Those who did not have a sled could catch a ride on the car.

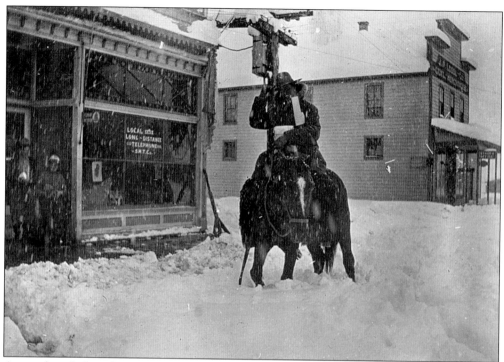

An unidentified cowboy is picking up the mail and a few supplies in Wisdom during a January 1910 snowstorm.

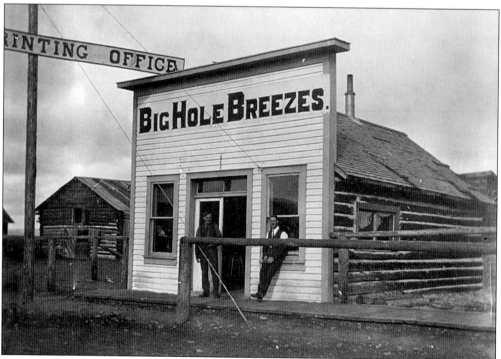

The *Big Hole Breezes* publication operated from 1889 to 1923 in Wisdom, keeping the Big Hole residents informed of community and national events.

Elk Horn Hot Springs, located at the head of Grasshopper Creek in the 1920s, was a popular spot.

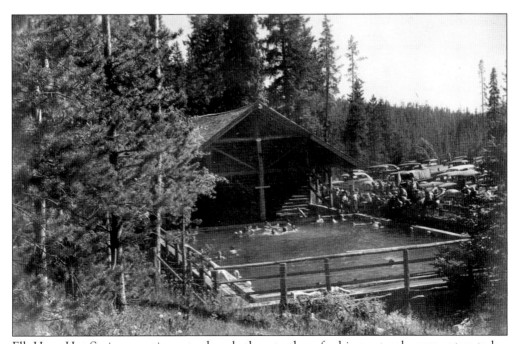

Elk Horn Hot Springs continues to draw bathers to the refreshing natural warm waters today. This picture was taken in the 1920s.

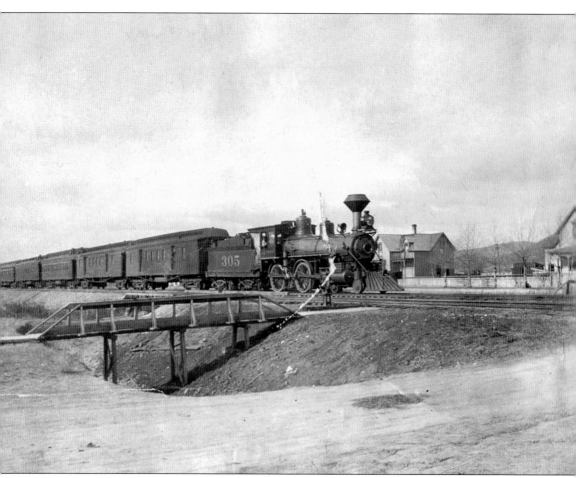

The Oregon Short Line No. 305 passenger train arrives at Dillon in 1905. This is a standard-gauge eight-wheeler. Blacktail Creek has not been rerouted yet. The homes in the background are near Reeder Street.

Sidney V. Dillon, president of the Union Pacific Railroad, was one of the trustees in charge of the construction of the railroad into Dillon. When the railroad construction crews moved north in March 1881, they took with them the temporary name of Terminus, which they named every town. Present-day Melrose then became Terminus. Dillon, which took its name from Sidney Dillon, would get its first post office on May 31, 1881.

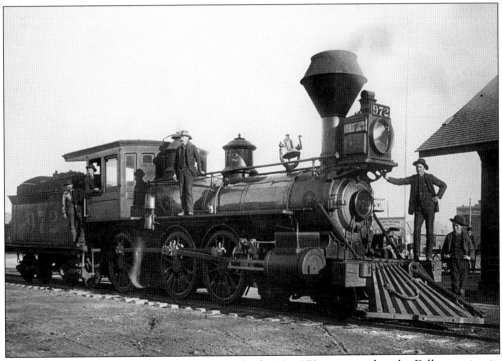

Oregon Short Line and Utah Northern 10-wheeler No. 972 is pictured at the Dillon station in 1889. A new station was built in 1908.

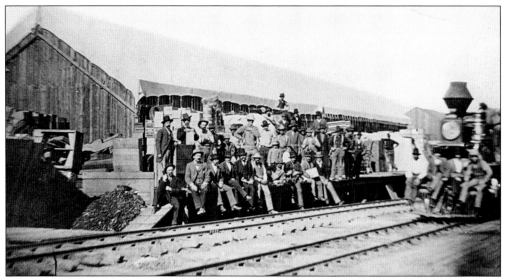

As the railroad moved forward with construction, each temporary town was called Terminus. It was mobile and made to be set up quickly. In this picture, Terminus is set up at what would be the town of Dillon. Note the canvas roof over the wood warehouse, convenient for easy setup and take down.

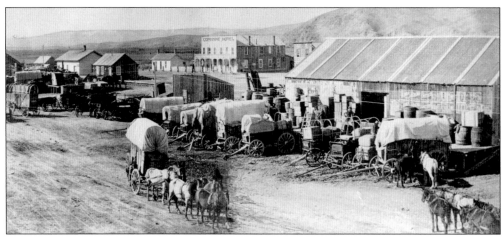

Freighter haulers are backed up to the warehouses that have been holding the freight brought in on the railroad. From here, they will take it to the outlying towns, such as Bannack, Grant, Twin Bridges, Jackson, and over to Virginia City, Butte, and Helena. Note the Corinne Hotel in the background. In 1880, some 33 million pounds of freight were shipped through Dillon, including 14,000 bushels of wheat.

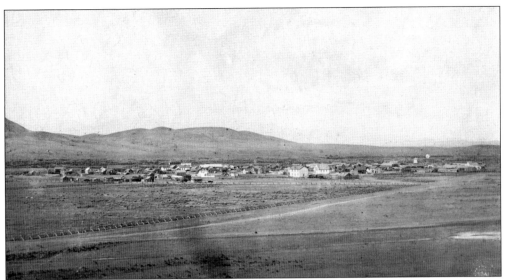

A view of Dillon in the 1880s is from a distance. The railroad's water tower and windmill can be seen on the right. The Corinne Hotel is to the left of center, and the schoolhouse is in the white, two-story building.

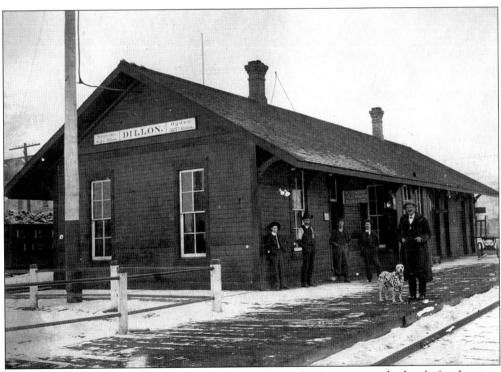

This is the first Dillon depot on the west side of the tracks. It was a standard style for the time, the late 1800s. Its 24-by-60 feet became too small by 1907, and a new depot was built but this time on the east side of the railroad, facing town.

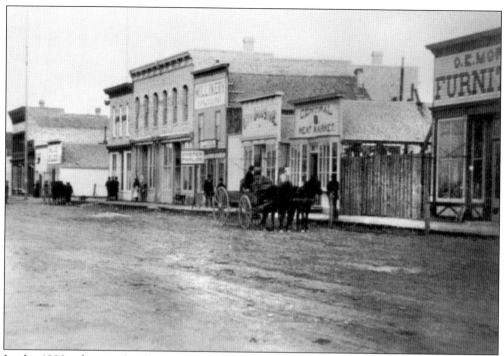

In the 1880s, the wooden buildings on Montana Street would be lost in a fire and would be replaced with brick buildings.

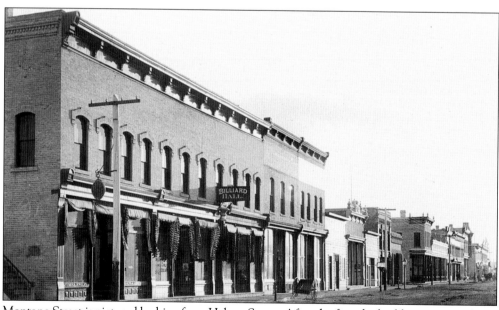

Montana Street is pictured looking from Helena Street. After the fire, the buildings were replaced with better, more permanent brick buildings, which are still standing 100 years later.

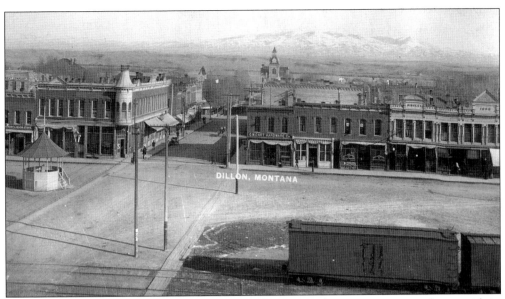

A 1909 picture of Dillon looks east down Bannack Street to the new county courthouse with its clock tower. Montana Street runs from left to right, parallel with the railroad.

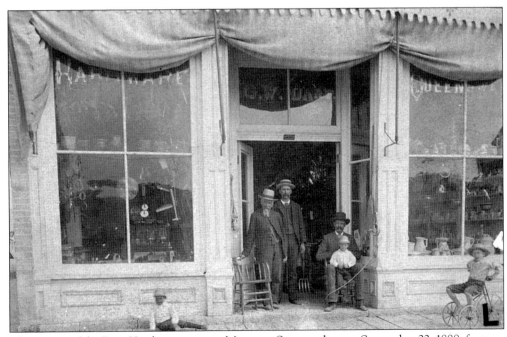

This image of the Dart Hardware store on Montana Street, taken on September 22, 1888, features adults, from left to right, George W. Dart, Fred W. Dart, and George W. Dart II.

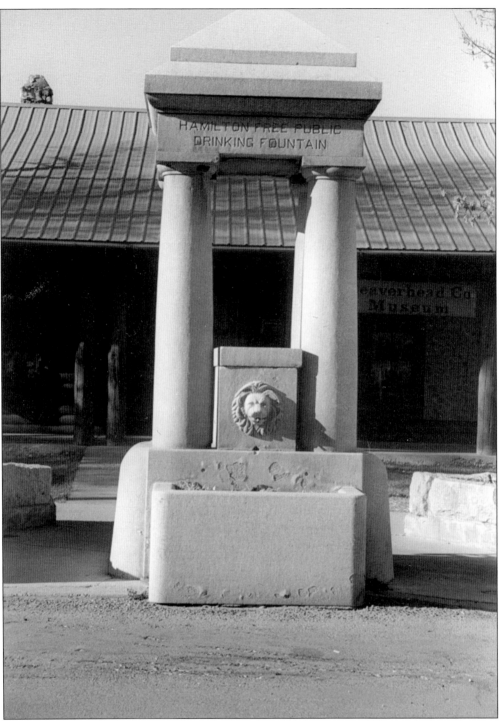

The Hamilton Fountain was donated to the people of Dillon by Mary J. Hamilton, the wife of Tom Hamilton. The Hamiltons had a ranch on Horse Prairie and never had any children. So when Tom passed away, Mary dedicated the fountain in his name because she noted that there was no place in town for people, horses, or dogs to get water.

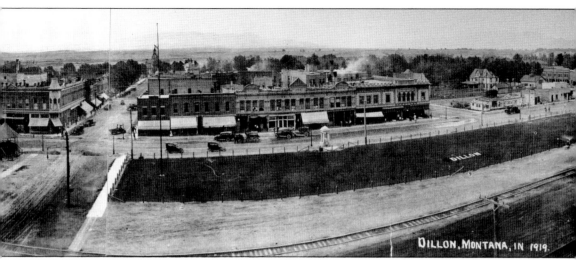

DILLON, MONTANA, IN 1919.

This view of Montana Street shows the Hamilton Fountain where it has stood for many years. Today the Beaverhead County Museum is behind the fountain alongside the railroad tracks.

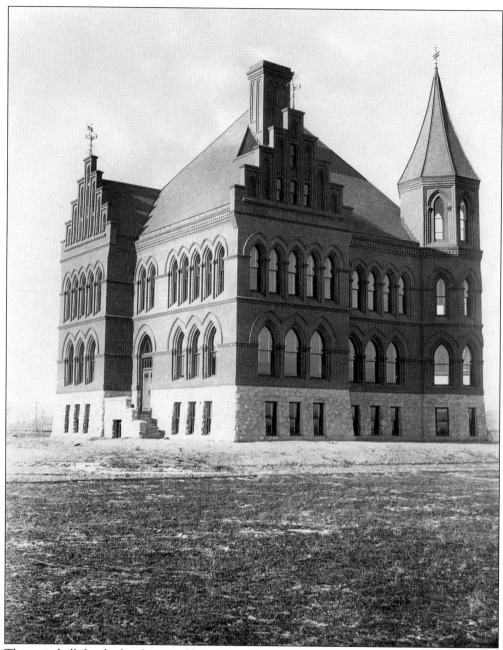

The main hall, finished and pictured here in 1897, was the original building of the Montana State Normal College. The 1895 state legislature funded construction of a classroom/administration building for the operation of the school. The cornerstone for the main hall was placed on April 7, 1895, and the impressive Gothic structure, although not completely finished, was occupied for school purposes in the fall of 1897.

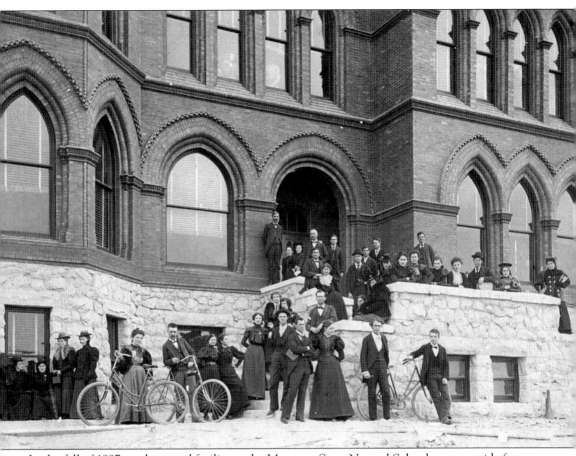

In the fall of 1897, students and facility at the Montana State Normal School come outside for a picture. Classes have started, although construction is not completely finished.

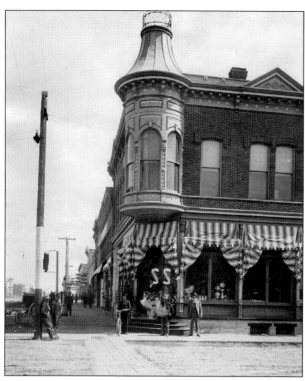

The northeast corner of Montana and Bannack Streets is seen here around 1890. Albert Stamm is standing in the doorway of his jewelry store. Standing on the wooden walk to the right is William Roe. The building became the Dillon City Bank in 1892. Later Skeets Cafe was located here until 1972. Now it is the Western Wok and Rusty Duck.

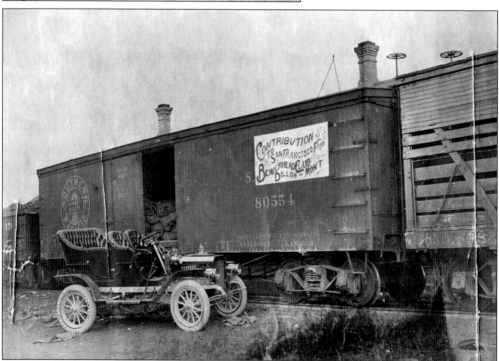

After the 1906 San Francisco earthquake and fire, food and donations were sent to aid those who had lost their homes. Dillon sent a rail car of donations by way of the Southern Pacific Railroad. Note the donating sponsor: the Beaverhead Club.

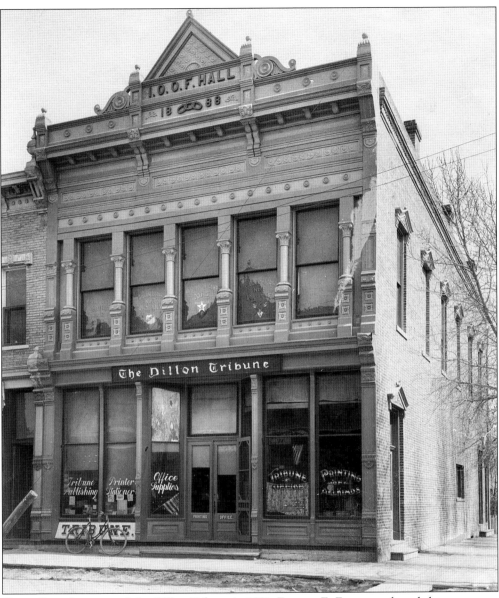

Hiram Brundage started the *Dillon Tribune* in 1881. Frances E. Foote purchased the newspaper in 1883 and ran it until his death in 1936. In March 1933, he celebrated 50 years as publisher of one of the oldest newspapers in Montana. Around 1906, the paper moved to 22 South Montana Street and has been there for 100 years. The State Bank occupied this building after the *Tribune* moved.

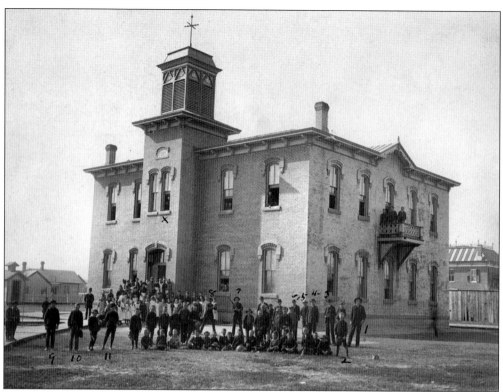

Here is the third schoolhouse and the first brick school in Dillon in 1888. This building is no longer standing; it was replaced by the Bagley School, which has also been removed. The location is now the downtown park across from the IGA grocery.

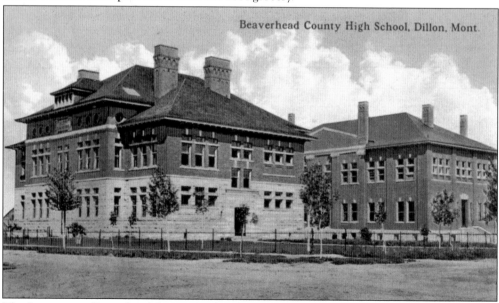

The first separate Beaverhead County High School building opened in 1901. The second building on the right is the gym. In 1939, both buildings were removed for construction of a new high school, which is still in use today.

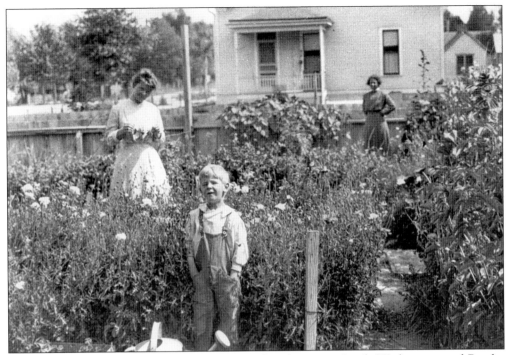

The Huber family is pictured in the garden at their home on South Washington and Reeder Streets in 1911.

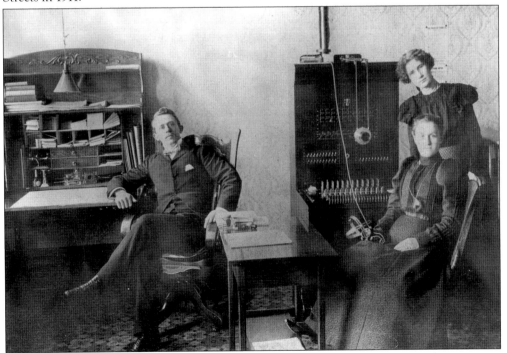

Dillon's first telephone service started in 1889. The Dillon telephone company employed one manager and two operators. From left to right are Charles Vaughn, the manager; a Mrs. Cunningham; and Minnie Conger (standing).

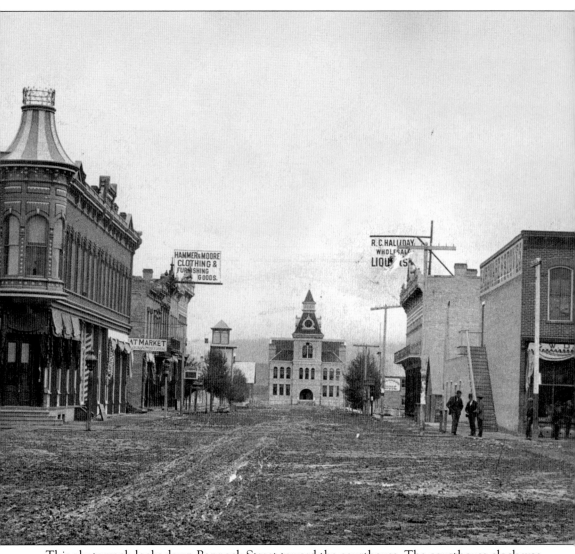

This photograph looks down Bannack Street toward the courthouse. The courthouse clock was installed in 1907 by the Huber brothers for $1,683.50.

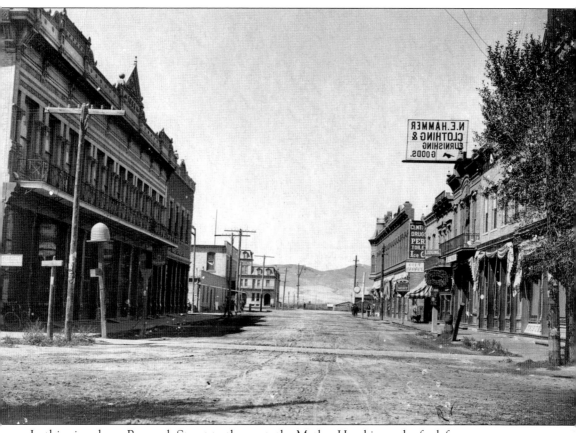

In this view down Bannack Street to the west, the Metlen Hotel is on the far left.

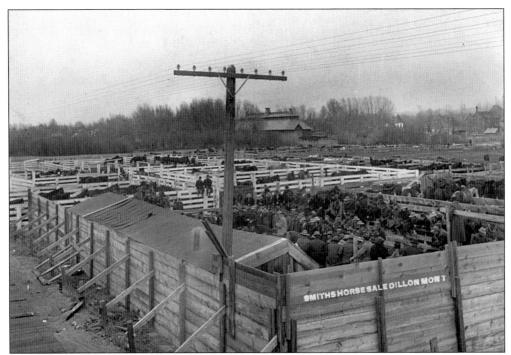

The horse industry was quite active in Beaverhead County, especially during the period from 1896 to 1921. The horse sales were held at an auction yard at the south edge of town just east of the railroad tracks. Around 1900, C. A. "Horse" Smith was the auctioneer and salesman. Buyers would come from all over the West. In the background is Poindexter and Orr's horse barn.

Horse sales were held semi-annually, and in 1906, more than 1,000 horses were sold. A man from Washington paid $750 for a team of draft horses, the highest price paid at this sale.

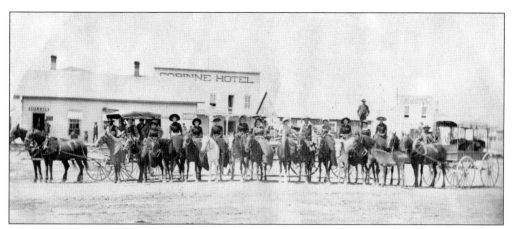

Capt. John Selway's Geyser Party in August 1885 includes, from left to right, a Reverend Norris, a Methodist minister; Carrie (née Carmichal) Gilliland; Clara (née Shively) Chapman; Georgia (née Johnson) Nuckless; Nettie (née Carmichal) Smead; Millie (née Coffin) Crowell; Anna (née Coffin) Nutting; Alma (née Thorpe) Harwood; Robert Selway Jr.; Billy Phillips; Harry Rash, a horse wrangler; and "Sailor Jack," a cook. This group rode to Yellowstone Park.

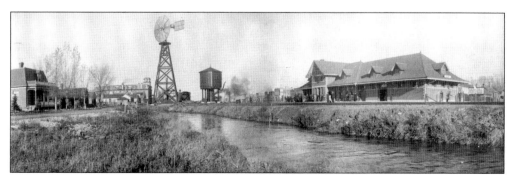

A new railroad depot was built in 1908. Blacktail Creek has been rerouted. A windmill and water tank keep the steam engines filled. The Metlen Hotel is left of the windmill.

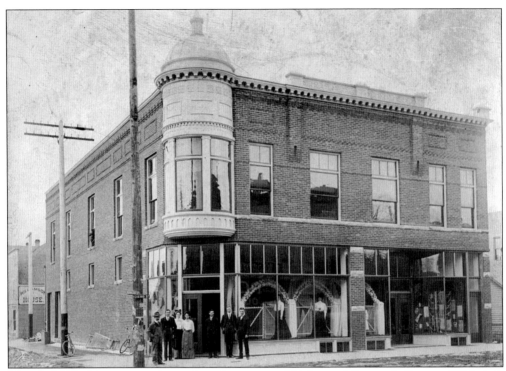

Charles Niblack's store was located at the corner of Idaho and Bannack Streets. Niblack is standing in the doorway. The Williamson Lodging House is on the left behind the main building, which is now King's parking lot. Peterson Drugs was located here. Now the building is owned by Max Hansen.

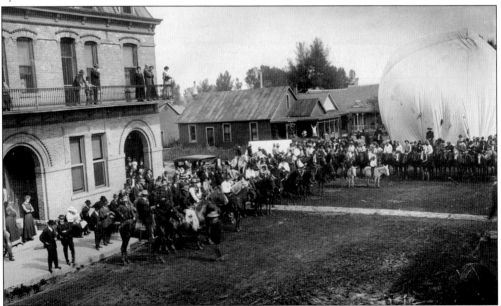

The first hot air balloon in Dillon sets up in front of the Metlen Hotel. The Metlen was built in 1898 after the Corinne Hotel, which originally stood here, burned in 1891. Both hotels were owned by Joseph C. Metlen, the older brother of David E. Metlen.

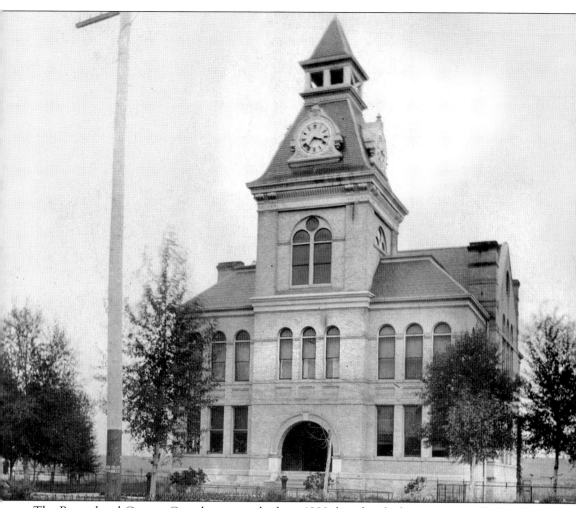

The Beaverhead County Courthouse was built in 1888, but the clock was not installed until July 1907.

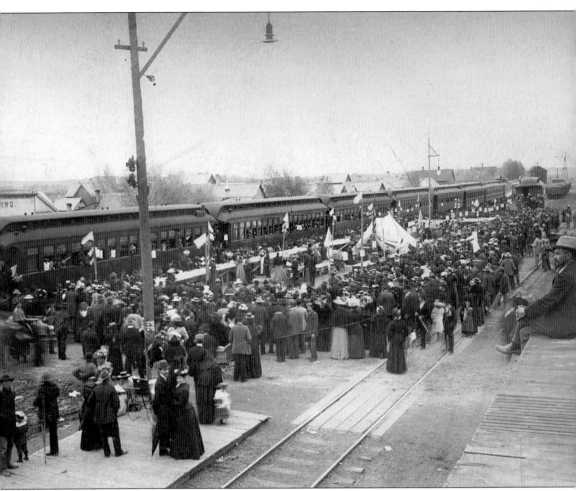

In 1898, a southbound train taking troops to San Francisco to fight in the Spanish-American War stopped in Dillon for a meal provided by the town. With the sinking of the battleship *Maine* in Havana, publisher William Randolph Hearst fueled American anger into a rush to war by publicizing it as a Spanish conspiracy. The business and religious communities, which had opposed war, switched sides. Because of journalism pressure, U.S. president William McKinley and Speaker of the House Thomas Brackett Reed were left almost alone in their opposition to the war. Thus, on April 19, 1898, Congress passed joint resolutions supporting Cuban independence and demanding Spanish withdrawal. War was declared on April 21, 1898. A large crowd of well-wishers have come to the station to support the soldiers as they head to war. The couple at the bottom looking toward the camera is Mr. and Mrs. Holden. The one-legged man at the left bottom is Clarence Axe, and the man sitting on the right edge of the picture is Dan Mooney.

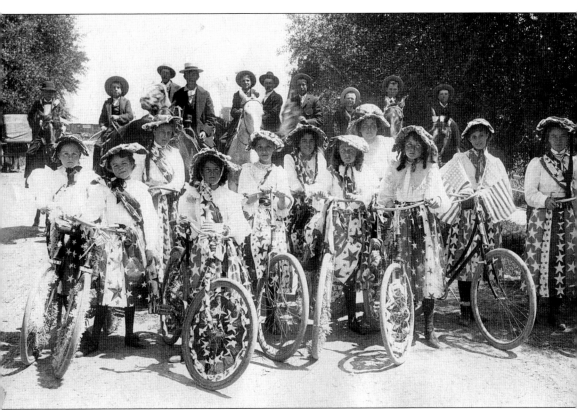

On the Fourth of July in 1898, the country was fighting the Spanish-American War. From left to right are (first row) Nancy Featherly (Mrs. E. D. White), Blanche Cartermole, Marjorie McLaughlin, Nancy McLaughlin (Canty), Lottie McIntosh (Mrs. Charles Hansen), Florence Carter (Mrs. Perry Backus), Glenn Cartermole, Anna Carter (Mrs. W. E. Brearley), Georgie Featherly, Blanche Morse (Mrs. Hollis Potter), and Sadie Graeter (Mrs. E. L. Poindexter); (second row) Herb Hansen, Jim McLaughlin, Earl Selway, Will McLaughlin, Guy Estes, Martin Innes, Joe Herman, Mike Fitzharris, Will Herman, and Roy Selway.

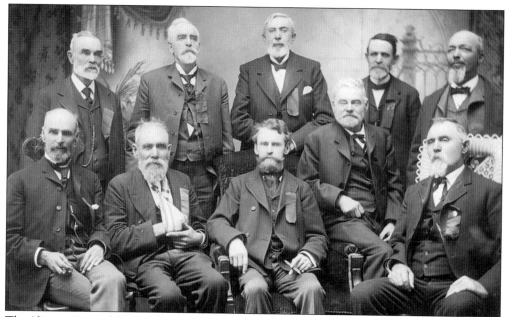

The 10 men pictured here were some of the early pioneers still living in 1902, when the pictured was taken by Henry D. Weenink in Dillon. Seated from left to right are F. H. Hamilton, Henry Edgar, William A. Clark, Augustus F. Graeter, and Con Bray. Standing from left to right are Joseph Shineberger, William Roe, Conrad Kohrs, Joseph A. Browne, and Martin Barrett.

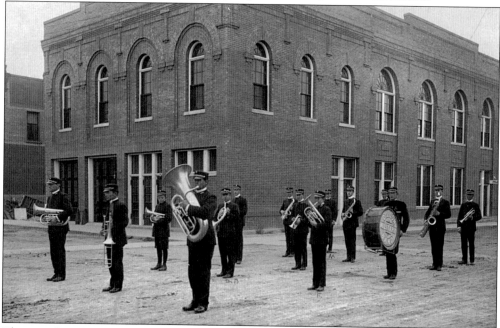

This marching band, standing next to city hall in 1915, includes, from left to right, (first row) Alf Cashmore, Marsel Coppin, and John Mayfield; (second row) unidentified, Ralph McFadden, and Dr. George Brownbeck; (third row) Anson Baxter, Dr. R. R. Rathbone (dentist), and Harold Snow (playing drums); (fourth row) George McFarland, Charlie Miller, and Gene Bond; (fifth row) two unidentified and L. A. Gregory (music teacher).

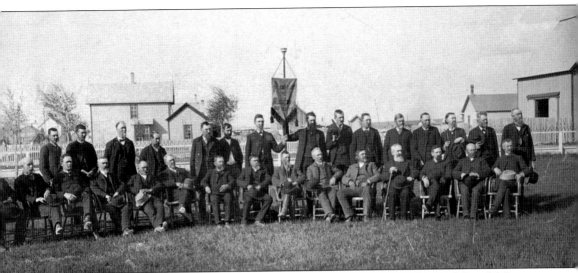

In April 1887, the first meeting of Beaverhead pioneers was held in front of the old frame courthouse in Dillon. From left to right are (seated) Phil Lovell, O. W. W. Rote, Dave Metlen, Joe Shineberger, William McIntosh, William Emerick, John F. Bishop, James Mansfield, William Oliver, Charles Ladue, Peter Wilson, Judge Caleb Irven, Joseph C. Kepler, Jacob Hardwick, and Robert T. Wing; (standing) Rufus H. Ferster, George H. French, A. F. Wright, Henry Pond, Con Bray, Harvey Sullivan, Joseph A. Browne, W. B. Carter, George W. Dart, Lafayette Scott, Arthur Sullivan, Henry Burfiend, J. R. Wilson, A. F. Graeter, and William Roe.

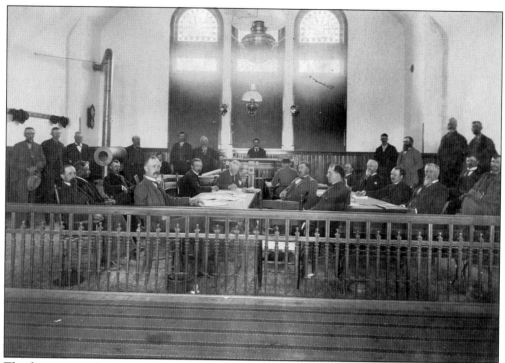

The first water-rights suit in Beaverhead County was fought in 1894 in the county courthouse. From left to right are (seated in background) A. S. Rife, Thomas F. Barrett, Ike Rife, and J. B. Poindexter; (seated at the table) John Forbis, H. R. Melton, Judge John Robinson, Thomas J. Monaghan, unidentified stenographer (back), W. S. Barbour, R. B. Smith, H. J. Burleigh, Judge T. J. Galbraith, Edward Norris, Judge William N. McConnell, Emerson Hill (back), and J. P. Murray; (standing) Sim Estes, unidentified, A. F. Graeter, Martin Barrett, L. J. Price, R. Z. Thomas, Clerk of the Court and Judge Frank Showers (seated), unidentified, W. R. Gilbert, W. S. Burnett, and T. B. Craver.

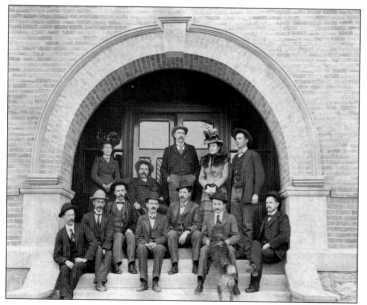

County officers gathered on the courthouse steps are, from left to right, (first row) Ray Conger, Charles Conger, Joe Poindexter, George Edinger, George W. French, Will Staudaher with dog, and Al Birdsley; (second row) Mayme French (Mrs. George French), Charles Padley, Pat (L. P.) Phillips, Bella Rife Orr, and Nick Staudaher.

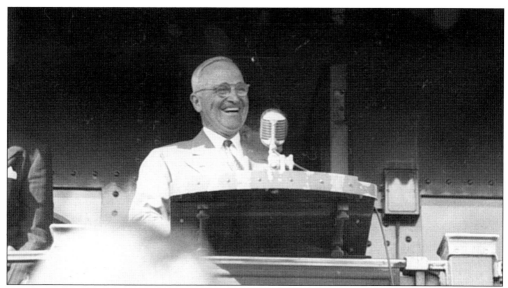

Harry S. Truman was the last U.S. president to travel by train. While on his famous whistle-stop campaign, "Give' em hell Harry" stopped in Dillon in June 1948 while on his way to Butte, Montana.

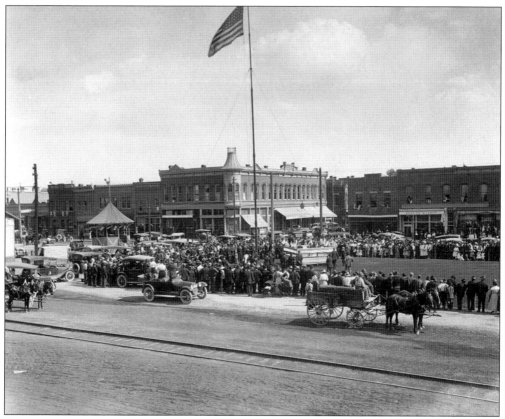

On September 19, 1917, the community came out in force to honor and send off 44 young men drafted from Beaverhead County to serve in World War I.

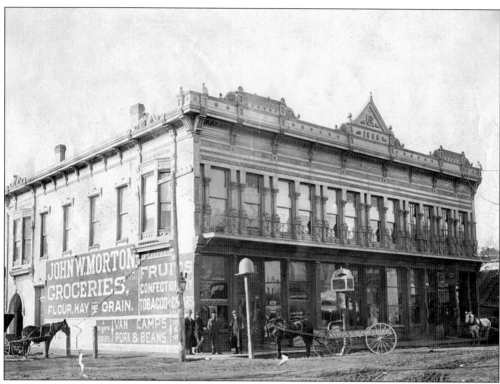

John W. Morton's Grocery stood at the southwestern corner of Idaho and Bannack Streets in 1890. Later this became the Huber Jewelry Store. The Masonic and Eastern Star members still hold their meetings in this building, with the entrance on Idaho Street at the far left of the photograph.

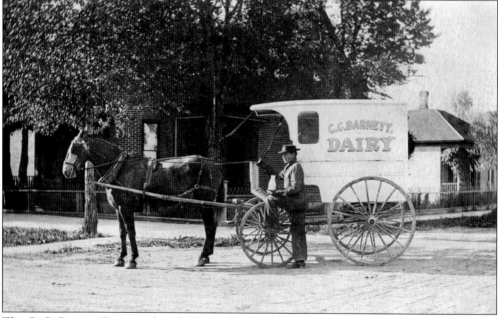

The C. C. Barnett Dairy used a reliable method of delivery and was one of the last to switch to the automobile.

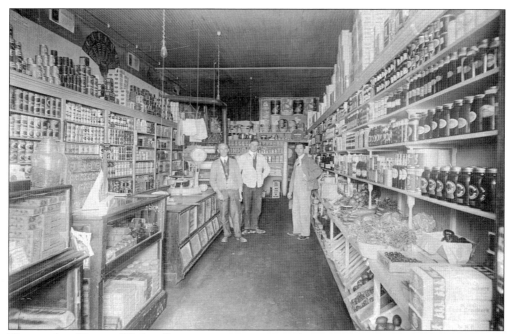

The inside of Eugene W. Bond's grocery store is pictured in 1920.

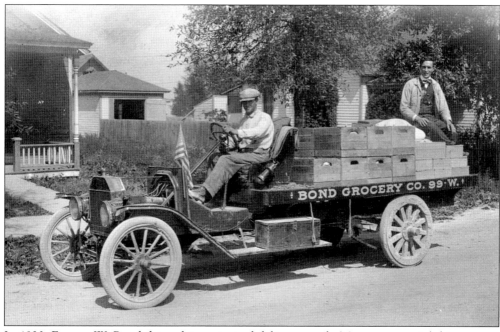

In 1920, Eugene W. Bond drives his motorized delivery truck. Most commercial drivers were cautious and courteous.

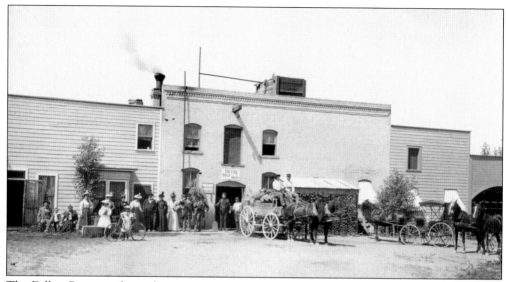

The Dillon Brewery, shown here in 1890, was owned and operated by Henry Burfiend and his brother. Some of the people in the picture are, from left to right, Henry Burfiend, Henry Burfiend Jr., Sophie Burfiend (seated in the black dress), Emma Burfiend (in white dress), and Bertha Burfiend (holding bicycle).

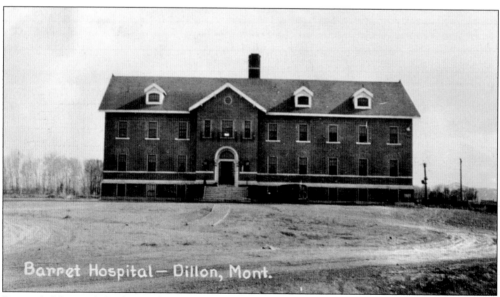

Barrett's Hospital, built on the former site of the Dillon Brewery, opened to the public in June 1923.

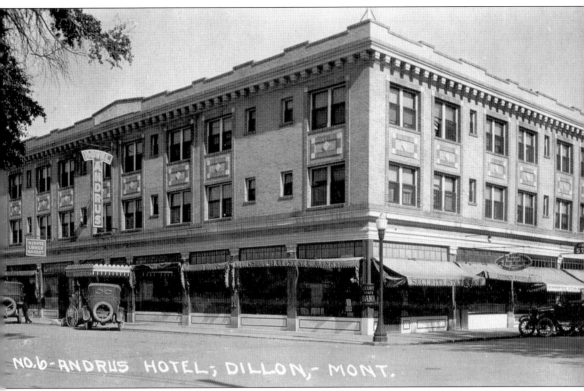

NO.6-ANDRUS HOTEL; DILLON,- MONT.

The Andrus Hotel was built in 1917 and opened on Valentine's Day in 1918. The new building was owned and operated by Harry E. Andrus and remained in the family for 52 years until it was sold in 1969. The construction cost was $165,000. It was one of the four leading hotels in Montana when it was completed. The building of pressed brick and cement was fireproof and modern in every way, including an automatic electric elevator. The two upper floors were comprised of 65 sleeping rooms, 46 of which had private baths. The first floor contained five small store or business rooms, a large tile-floor lobby, the hotel office, a barbershop, bar, café, dining room, and kitchen. The dining room tables were covered with the finest linen, china, and silver service, all sparkling from the light of crystal chandeliers.

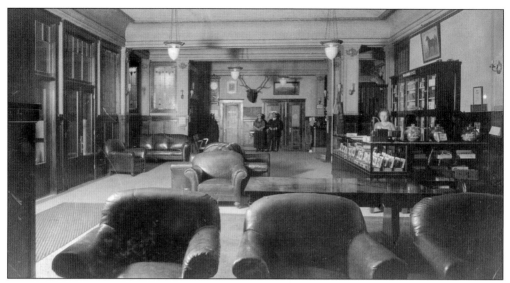

The Andrus Hotel lobby was filled with green leather chairs and stained-glass windows. On the right is a fully stocked cigar stand, and around the corner is an electric elevator. Across the lobby was the public stenographer's office, where Myrle Erwin could draw up a contract or bill of sale. She maintained an office here until 1950.

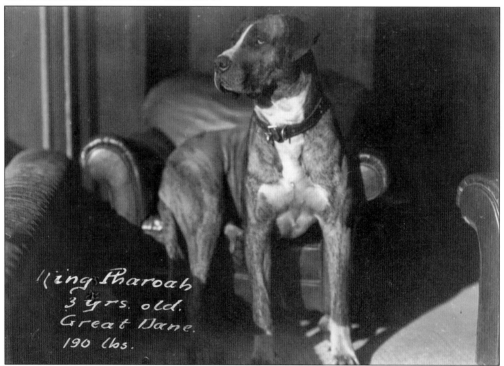

King Pharoah
3 yrs. old.
Great Dane.
190 lbs.

The Andrus had an unusual bellboy, or bell dog, that would carry suitcases in his mouth. All suitcases were fair game at the depot, even if the passenger was not staying at the Andrus. King Pharoah was a 160-pound Great Dane, and when not carrying suitcases, he would sit in one of the lobby chairs with his behind on the chair and his front feet on the floor. This was years before the famous television dog "Scooby Doo." Who knows? Maybe the idea came from King Pharoah.

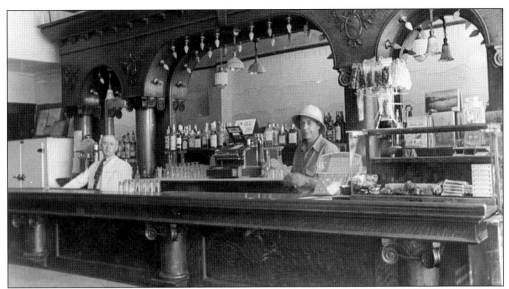

The bar at the Andrus Hotel was built by the Phoenix Furniture Company in Eau Claire, Wisconsin, in 1870 and was shipped via railroad to Corinne, Utah, then carried to Bannack by wagon. In 1910, it was moved to Dillon by Chris Snyder and served in a saloon on Montana Street until 1917, when it was moved to the Andrus. It is made entirely of oak except for the solid 22-foot mahogany board that makes the bar top; it all weighs about 1,500 pounds. Here many business deals were made. During Prohibition, the bar served as a soda fountain. Frank Madden is on the left, and Farnum Schuyler is on the right. Farnum managed the hotel from 1954 to 1969, when it was sold to M&M Enterprises. It was sold again in 1979 to Doug Harvey and was remodeled into a furniture store and re-christened the Andrus Plaza. The bar is now in the Metlen Hotel on the west side of the tracks and can be seen in the back bar.

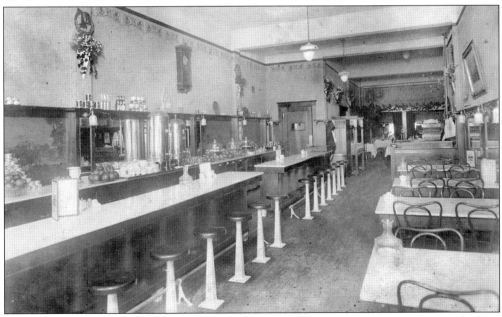

The café at the Andrus Hotel was for those not wanting to use the dining room or were looking for something more economical. Many locals would stop here for a quick bite to eat.

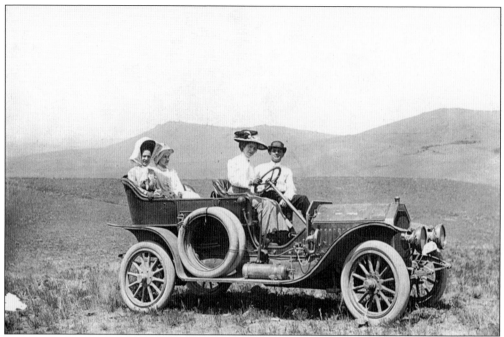

Out for a ride is Bertha Burfiend at the wheel, while a Mr. Knight from Chicago gives guidance. In the backseat (from left to right) are Emma Burfiend Bates and Clara Hughes Graeter.

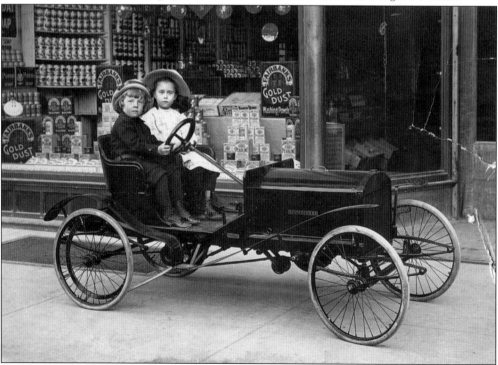

This picture is in front of the Olmsted-Stevenson General Store in 1910. This children's car—"Browniekar"—was the prize for a contest sponsored by the store. Young Tom Olmsted and Mary Schoeborn are taking it for a test ride.

Five

FARMERS AND RANCHERS

Most of the accounts in recorded history credit Capt. Richard Grant, his Native American wife, and their two sons, Johnny and James Grant, with bringing in some of the first cattle to southwest Montana and Beaverhead County. Captain Grant was the former Hudson's Bay agent at Fort Hall, Idaho. In 1850, the Grants were trading on the Oregon Trail with the weary emigrants. Worn-out cattle and horses and miscellaneous equipment could be purchased at low prices. The livestock was driven north to Beaverhead County to rehabilitate in the milder winters, fatten up on the native grasses, and shelter up in the willows, alders, and cottonwoods along the streams. In the spring, the Grants would return to Fort Hall and the emigrant trail to sell or trade to the weary pioneers—one good head for two jaded ones. The first Montana cattle herds began with these eastern descendants of old hardy stock, Durham and Shorthorns, breeds that originally came from Northern Europe and England. The famous Texas Longhorns, descendants of Spanish cattle, would not come up from Texas until the latter part of the 1860s. Thus, by 1862, small herds existed before the gold strikes to supply meat to the miners and settlers rapidly moving into the area. Sheep ranching began in 1869 when John F. Bishop and Richard Reynolds brought a band of 1,500 sheep from Dalles, Oregon. During the 1870s, sheep gradually became more plentiful. By the time Dillon was founded in 1880, numerous ranchers, including Poindexter and Orr, William Jones, Tommy Haw, A. Bessette, Jerome Bishop, and the Selways, to name a few, had sheep herds. The railroad offered the opportunity for improved breeding with rams arriving from Canada, Ohio, and Michigan, and the ranchers began breeding to a type that suited their individual tastes. By 1900, Montana was the largest wool producing state in the United States, with four million head producing 26 million pounds of wool. After 1909, the industry decreased to less than half, and by 1921, there were less than two million head of sheep.

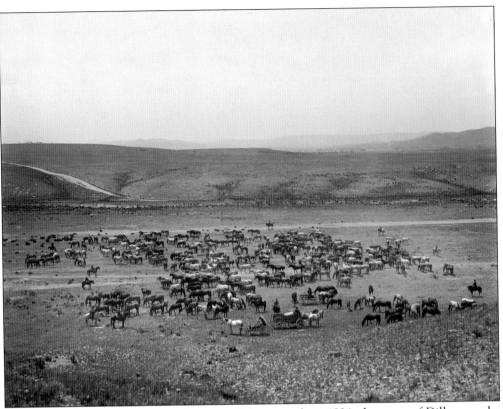

In a view of a horse roundup on the James Selway ranch in 1894, the town of Dillon can be seen in the background. Horses not needed during the winter were put out to pasture and were rounded up in the spring.

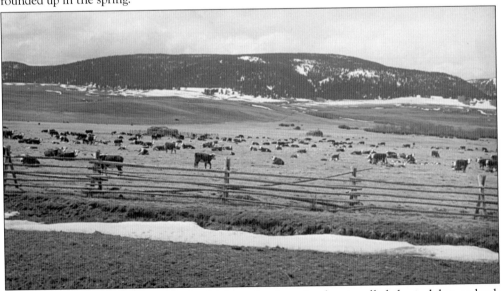

Fences reflect the materials at hand, which is why there is what is called the jack-leg, or buck and pole, fence. Beaverhead County is lodgepole pine country. People use what they have in abundance.

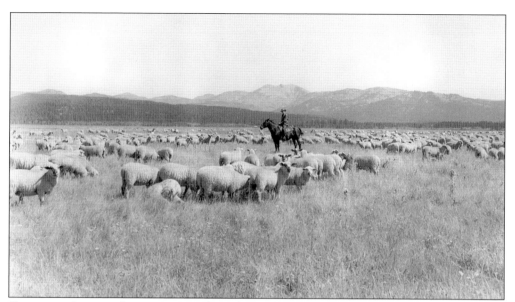

Sheep were kept on the range as much as they could, with lambing generally in March so the lambs could be sold in July. Most of the sheep sold were going out as five-month-old lambs, referred to as feeder lambs (that is, they would be fattened somewhere else).

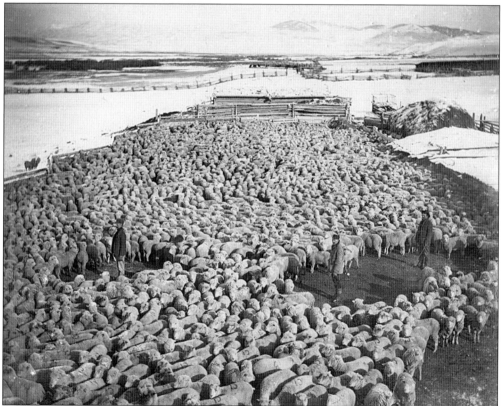

In the winter, the breeder ewes had to be fed, which could be expensive, depending on how much hay was needed.

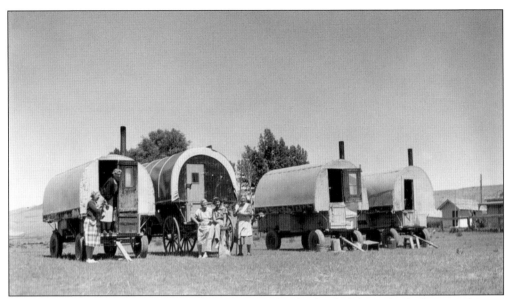

Sheep wagons were the first travel trailers; however, the shepherds did not think they were having fun. This was a way of life. Originally, the wagons had wagon wheels like the second wagon from the left. It was later that the rubber tires were added, and it sure made the ride smoother.

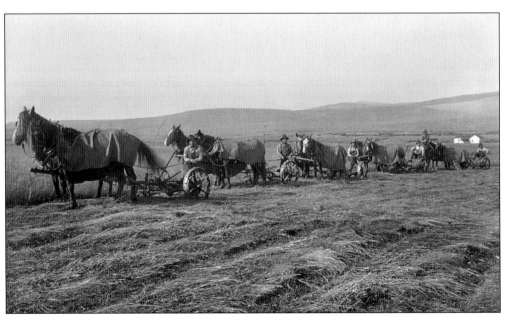

These five mowing machines are cutting hay in Big Hole Valley. Because of the pesky black flies, these horses have covers to help keep them off. The Big Hole is famous for its native grass hay and large black flies.

112

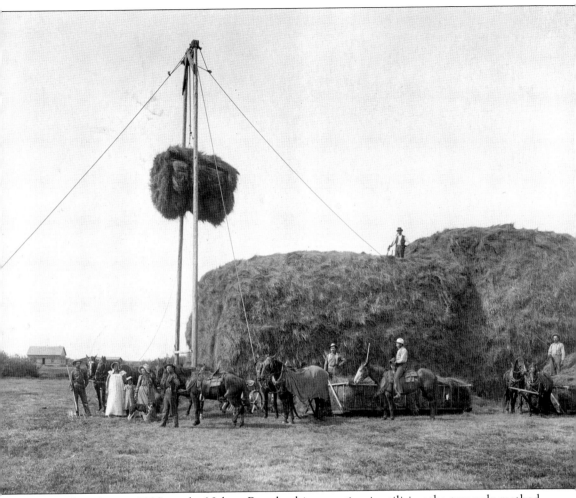

Stacking hay in 1908 on the Nelson Ranch, this operation is utilizing the two-pole method. The hay is being brought in from the fields on hay boats, which use skids instead of wheels. The hay is then lifted on a net. Then the poles are allowed to fall 30 degrees into the stack, causing the hay bundle to swing out over the stack, which at the exact time is released, falling on top of the stack.

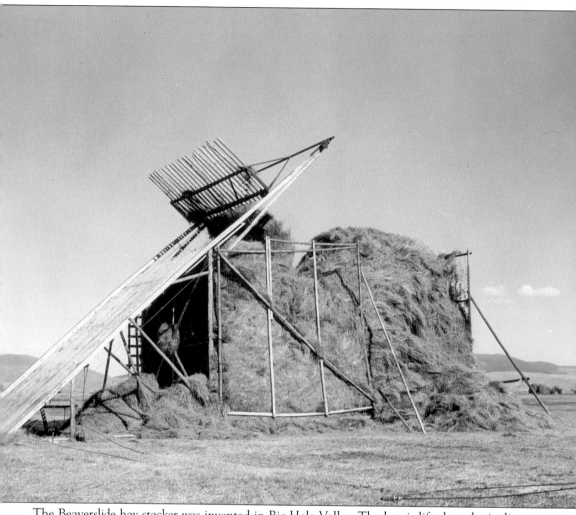

The Beaverslide hay stacker was invented in Big Hole Valley. The hay is lifted up the incline, falling through the hole onto the stack. The horses that pulled the rake to the top are just out of the picture on the right. A man with a pitchfork stands on the stack to place the hay evenly in the corners so the stack will not fall over.

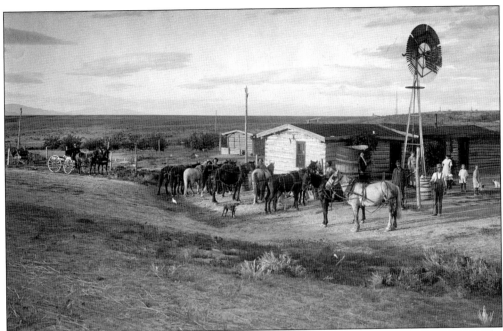

On the Norman Holden ranch on the east bench, the early morning sun casts long shadows as the men get the teams ready for the day. Everyone is up because there are chores to do. In back of the cabin are crab apple trees, which did well and made excellent apple butter. Holden experimented with dryland farming practices through Montana State College in Bozeman.

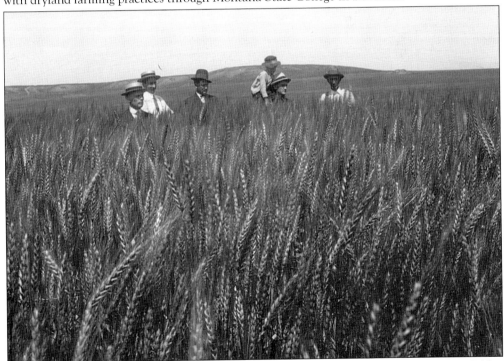

The tallest wheat ever grown on a dry farm was that grown by Norman Holden in 1912. Holden is on the right; the rest of the men are from Montana State College.

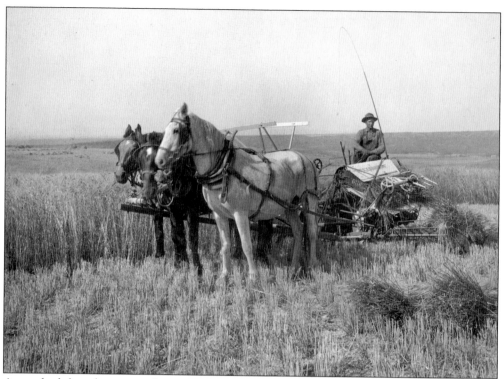

A standard three-horse team harvests wheat with a McCormick binder.

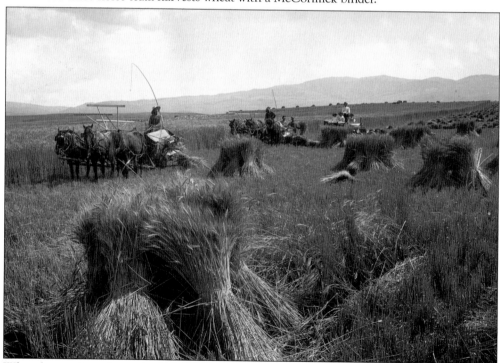

When harvesting wheat, the binder would cut and tie the wheat into bundles called shocks, which were stacked by hand standing up, in case of rain.

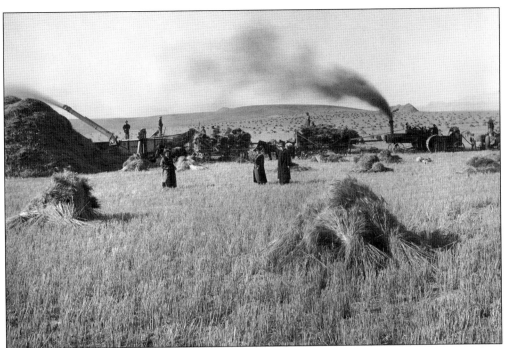

The belt on this wheat thrasher was 60 to 80 feet long to keep the steam tractor well away from the thrashing operations because of the fire danger. Fire was always a real threat to the dry grain, along with the volatile dust.

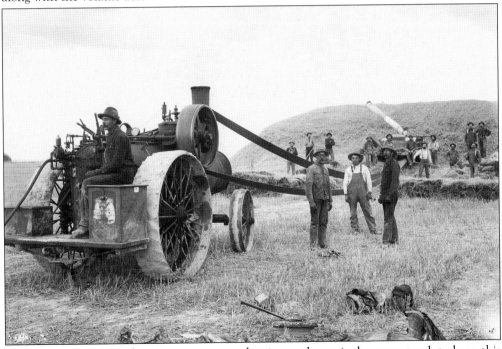

In this image of a thrashing steam tractor, what is not shown is the water truck to keep this steam tractor supplied. On the ground is part of the wood pile. Wood or coal was used to make the steam.

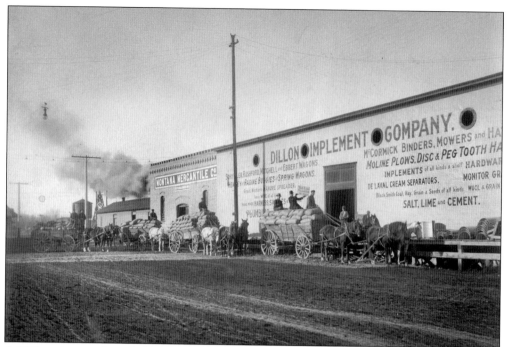

A 1911 grain crop from dryland farms on the east bench is being brought in for shipping on the railroad. Note the water tank and windmill, along with the smoke from the engine on the other side of the building.

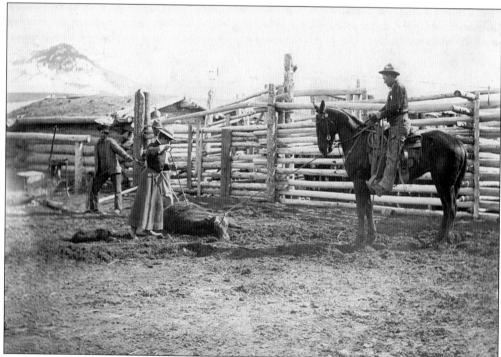

It is branding time on the Craver Ranch, and everyone pitches in. Spring was usually branding time before the calves went out with the cows to summer pasture.

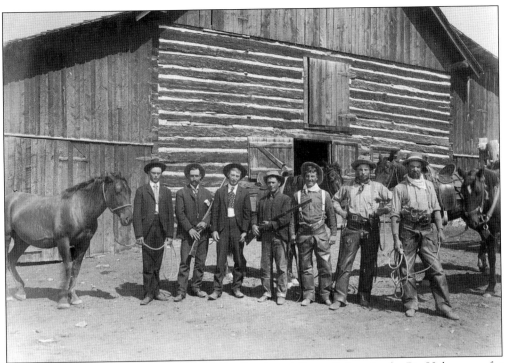

Cowboys at the Sunnyside Ranch, owned by Frank and Gorge Buhrer in the Big Hole, pause for a picture on a Sunday morning in 1905. From left to right are Roy Robinson, Ed Nyhart, Alex Fraser, Billy Freeman, Billy Fraser, Fred Wolfer, and Sam ?.

This image of people playing croquet on a ranch in the Big Hole is a rare photograph of recreation on the often lonely homesteads.

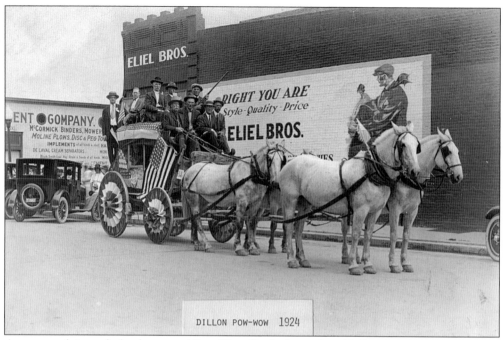

DILLON POW-WOW 1924

A stagecoach is ready for the annual Pow Wow (Rodeo) parade in Dillon. In 1931, the name was changed to Rodeo.

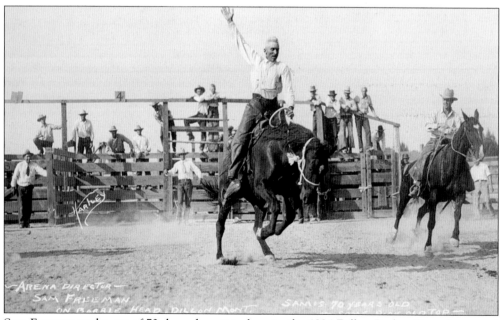

Sam Freeman at the age of 70 shows how it is done in the 1934 Dillon Rodeo. Sam also served as the arena director.

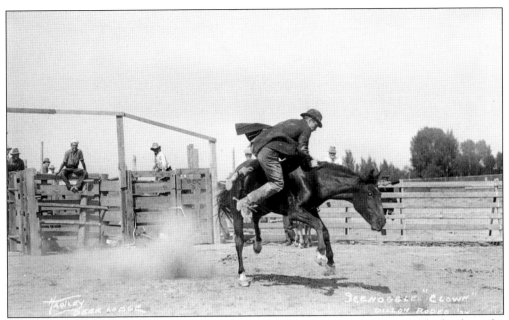

The rider is holding on to whatever he can since he has no saddle or reins. Look closely at the man on the fence wearing the sailor hat; this spectator looks as if he just got out of the navy. He appears again in the lower right-hand corner in the picture on page 122. See if you can find the only man waving a sailor hat.

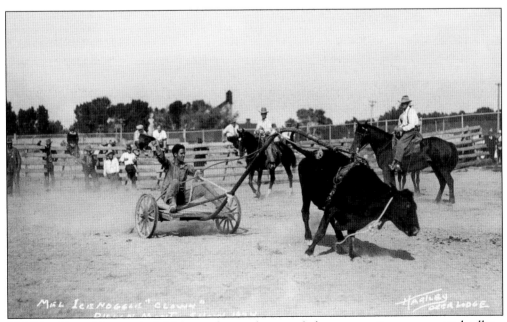

Mel "the Clown" Icenoggle (which may be a rodeo name) shows a creative cow-powered sulky.

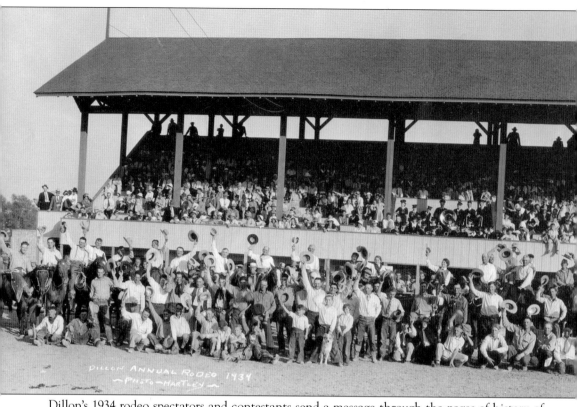

Dillon's 1934 rodeo spectators and contestants send a message through the pages of history of how they felt back then since they are not here in person to talk about it.

Six

USS BEAVERHEAD

During World War II, new cargo ships for the U.S. Navy were named after counties. The naming went, as most military order goes, in alphabetical order. On January 3, 1945, a new Alamosa-class cargo ship was commissioned at Richmond, California: the USS *Beaverhead* (AK-161), under the command of Lt. Cmdr. Olin F. Weymouth. The ship was 388 feet long and 50 feet wide, and with a single screw (propeller), she cruised at 11.5 knots. She was armed with one 3-inch, dual-purpose gun mount and six 20-millimeter guns. On February 20, 1945, the *Beaverhead* left San Francisco, California, with a crew of 85 for service in New Guinea, the Philippines, and the Admiralty Islands. For eight months, she supplied various American bases. She returned to New York on January 30, 1946, and was decommissioned in Norfolk, Virginia, on March 8, 1946. Her top speed, 11.5 knots, equals 13.23 miles per hour. Although not considered a fast ship, she was a workhorse and was important in keeping supplies moving. Information about the USS *Beaverhead* was provided by former crew member Stuart Schmidt.

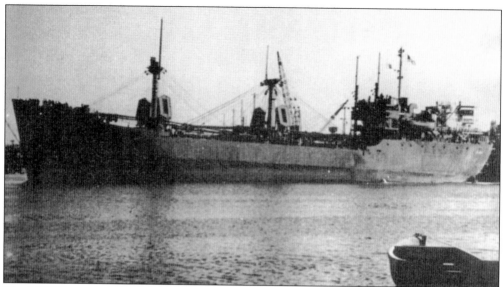

The USS *Beaverhead* was a World War II navy cargo ship that served during the last year of the war.

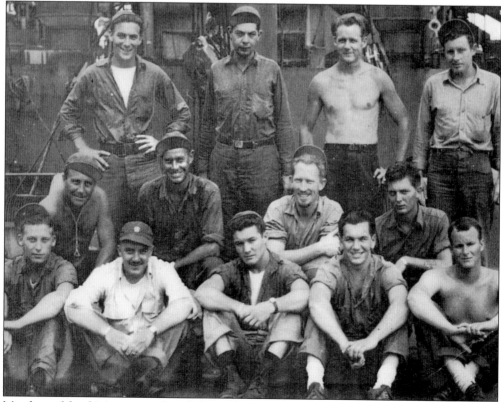

Members of the ship's crew are, from left to right, (first row) Jack Miller RM3, Richard Ault LTJG, Edward Wagner, Joseph Goody YM3, and Warren Greer QM2; (second row) George Surface QM1, unidentified, Garrett Hartsuyke CRM, and Glen Smith SM2; (third row) Stuart E. Schmidt RM2, James Keeley YM1, Reed McKinnon, and Jack Durham PHM1. (Courtesy of Stuart Schmidt.)

Seven

BEAVERHEAD COUNTY MUSEUM

The first concept of a museum for the county can be found in the meeting notes of the Beaverhead Chapter of the Daughters of the American Revolution (DAR). In December 1927, Phoebe C. Anderson (Mrs. A. L. Anderson) presented the idea of a room in the courthouse fitted with items, books, and papers. Anderson and Elfreda Woodside met with the county commissioners and were granted a room at the courthouse. Through the 1930s and 1940s, the DAR and members of the Beaverhead County Mining Association began to collect artifacts, manuscripts, photographs, and other memorabilia that represented the history of the county. Exhibits were presented at the courthouse and at Montana State Normal College. Space became a continuing problem. On January 9, 1942, the Beaverhead County Museum Association was incorporated, and on October 1, 1947, fund-raising was started to construct a permanent facility for the museum collection and the newly formed Beaverhead Chamber of Commerce. In less than one year, the $13,500 needed was raised; contributions came from every corner of the county. In 1948, the ownership of the artifacts was transferred to the county for proper preservation, storage, and display in a suitable place to be open to the public as a museum. On April 16, 1949, ground was broken on land leased from the Union Pacific Railroad for the placement of the museum building. On March 19, 1950, the museum building was dedicated and opened to the public. Elfreda Williamson Woodside was the first director. The chamber of commerce shared space in the building and kept it open during the tourist season. In the winter, it was open during the chamber office hours. In January 1967, the museum was expanded with the addition of the Torrey Lodge. In 1975, Elfreda Woodside retired.

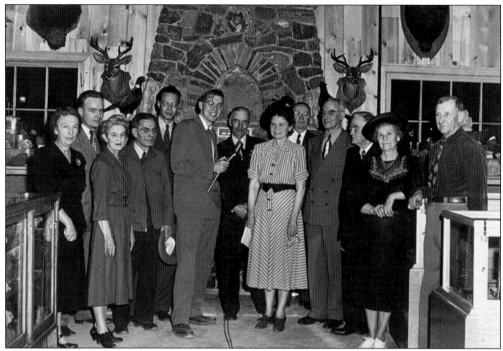

The dedication of the new Beaverhead County Museum on March 19, 1950, included, from left to right, Constance Barrett, Bob Watson (the president of the chamber of commerce), Nancy Barrett, Arthur Contway, Fielding Graves, ? Buck (a radio announcer for KPOR in Butte), Parke Scott, Elfreda Woodside (the first director of the museum), Frank Tyro, Gene Bond, Denton Oliver, Sadie Poindexter, and Fred Woodside.

The new Beaverhead County Museum opened to the public in 1950. Owned and operated by the county, it is supported by local taxes.

The committee that worked collectively to put together the material for this book is, from left to right, Ben Goody of Glendale, Montana; Joann McDougal, former Dillon librarian, museum volunteer, and researcher; Betty Meine Hull, museum director; and Steve Morehouse, researcher.

ACROSS AMERICA, PEOPLE ARE DISCOVERING
SOMETHING WONDERFUL. THEIR HERITAGE.

Arcadia Publishing is the leading local history publisher in the United States. With more than 4,000 titles in print and hundreds of new titles released every year, Arcadia has extensive specialized experience chronicling the history of communities and celebrating America's hidden stories, bringing to life the people, places, and events from the past. To discover the history of other communities across the nation, please visit:

www.arcadiapublishing.com

Customized search tools allow you to find regional history books about the town where you grew up, the cities where your friends and family live, the town where your parents met, or even that retirement spot you've been dreaming about.